Contents

Map of the Caravan Routes and Art Centres in Central Asia 6-7

INTRODUCTION 11

THE BEGINNINGS OF PAINTING IN CENTRAL ASIA (Mirān) 19

THE AESTHETICS OF LIGHT 31

PJANDŽIKENT AND THE INFLUENCE OF SOGDIANA 43

THE SCHOOL OF KHOTAN 53

THE MAIN CENTRES ON THE NORTHERN CARAVAN ROUTE 69

THE TURFĀN GROUP 95

CONCLUSION 115

Documents 124-125
Bibliography 127
General Index 129
List of Illustrations 133

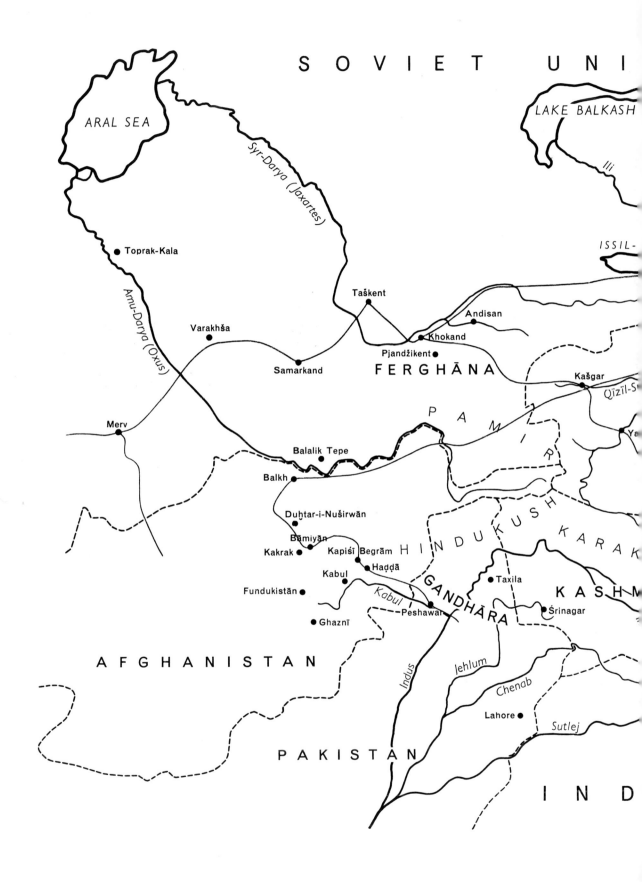

TREASURES OF ASIA

CENTRAL
ASIAN PAINTING

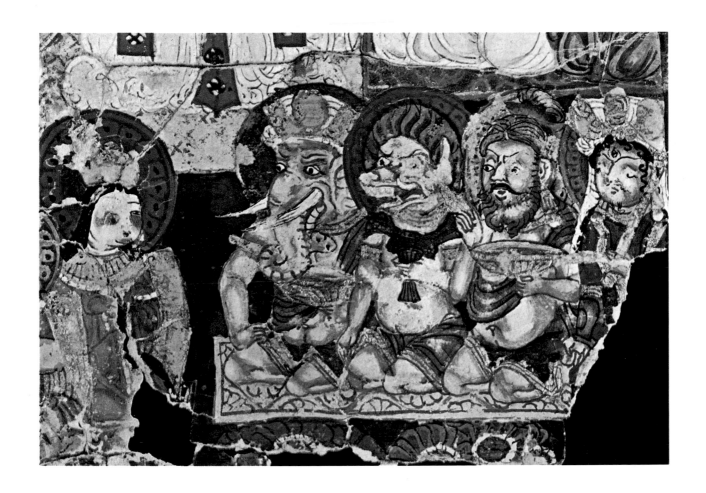

TEXT BY MARIO BUSSAGLI

Professor at the University of Rome

Translated from the Italian by Lothian Small

★

Colour plate on the title page:

Detached leaf of a Manichaean Manuscript, painted on both sides, detail.
Painting on paper from Qočo. Eighth-ninth centuries. (Width 2″)
1 B 4979, Indische Kunstabteilung, Staatliche Museen, Berlin.

★

ISBN 0 333 25318 3

This edition published in Great Britain in 1978 by
MACMILLAN LONDON LTD
London and Basingstoke

Associated companies in Delhi, Dublin,
Hong Kong, Johannesburg, Lagos, Melbourne,
New York, Singapore & Tokyo

PRINTED AND BOUND IN SWITZERLAND

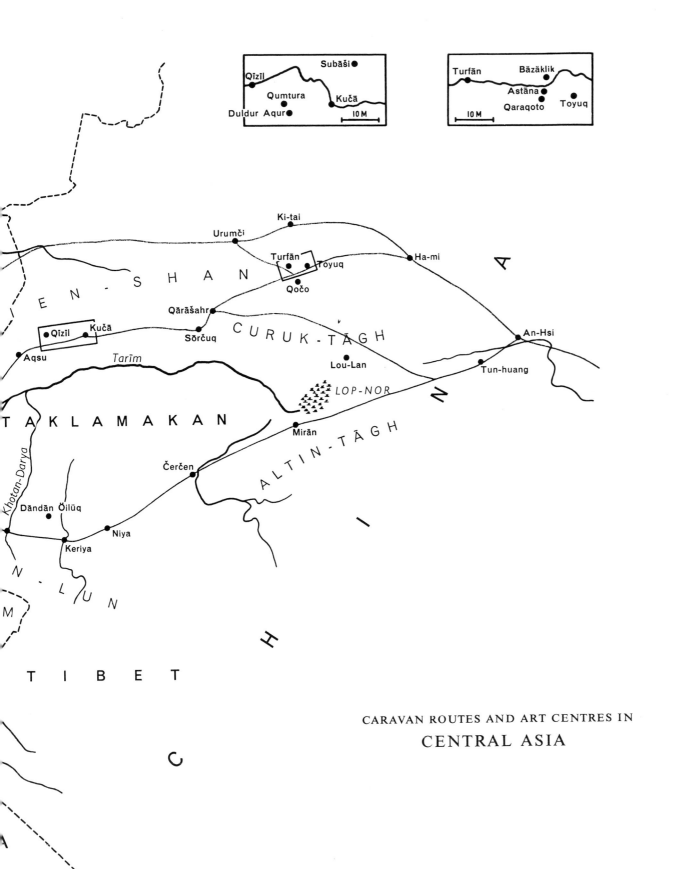

Inset 1 (left):

Qïzïl Subāši ●

Qumtura

Duldur Aqur ● Kučă

10 M

Inset 2 (right):

Turfān Bäzäklik

Astāna

Qaraqoto Toyuq

10 M

Main map:

T I E N - S H A N

Ki-tai

Urumči

Turfān Toyuq

Qočo

Qārāšahr

Qïzïl Kučă

Sörčuq

CURUK-TĀGH

Aqsu

Tarīm

Ha-mi

An-Hsi

Lou-Lan

LOP-NOR

Tun-huang

TAKLAMAKAN

Khotan-Darya

Mirān

Čerčen

ALTIN-TĀGH

Dāndān Öilüq

Niya

Keriya

K U N - L U N

T I B E T

CARAVAN ROUTES AND ART CENTRES IN

CENTRAL ASIA

Central Asian Painting

THE pictorial art that concerns us here is confined to that of the southern part of the region called Upper Asia. In the oases of these desert wastes, along the valleys of rivers winding through the sands, wherever networks of irrigation canals were feasible, there grew up highly cultured communities of merchants and middlemen who earned their living from the caravan traffic plying between the classical and Byzantine west on the one hand and the great states of farther Central Asia on the other. For art to flourish at all it had to depend largely on the commercial exchanges and other contacts made in this region.

Central Asia is bounded on the south and east by the great sedentary civilizations bordering on those virtually impassable mountain ranges which, from the Caspian Sea to northern China, formed a more or less effective barrier against the nomad hordes continually threatening to sweep down from the north. Across this part of Central Asia, today divided between the Sinkiang province of China and Russian Turkestan (i.e. the Soviet Socialist Republics of Turkmenistan, Tadžikistan, Uzbekistan, etc.), went the shortest and easiest lines of communication between east and west, lines which were soon to be developed into transcontinental caravan routes connecting China with the ports of the eastern Mediterranean, and, by way of branch roads, with India on the south and the Urals and Black Sea ports on the north.

The inhabitants of Central Asia thus became as a matter of course the principal agents in a commercial traffic so intense as to prove essential to the political equilibrium of Europe and Asia. The nomadic empires of the north and the sedentary ones of the south—from Iran to China—long vied with one another for this region, but only with a view to controlling the traffic without draining away its wealth. It is precisely for this reason that the small kingdoms of Central Asia, often populous city-states flourishing in the shadow of the oases, were able to survive. But the continual ferment of these powerful forces was such that the indigenous peoples, remnants of a migration of Indo-European tribes, were supplanted in the course of centuries by infiltrations of Turkish tribes who fell heir to their civilization. In the western part the Arab invasion with its pointlessly cruel fury annihilated kingdoms and cultures, flinging back to the aridity of the barren sands rich wide lands won from the desert by centuries of patient labour.

The history of this immense region, extending from the basin of the ancient Oxus (today the Amu Darya) to the western frontiers of Chinese Kansu bordering on Outer Mongolia, is a tale of bloodshed, of ferocious fighting between different racial groups, of ephemeral hegemonies. Iranians and Greeks, Indo-Scythians, Chinese, Tibetans and Arabs all in turn appear as the dominant power along the routes traced by the caravans, all meeting with local resistance in the oasis towns and the deserts, contending against the nomad hordes from the north or fighting among themselves in efforts to impose their own hegemony. In such ways were determined the rise and fall of kingdoms and empires, destruction and massacres without end, heterogeneous coalitions conspicuous for violence and ferocity.

The warlike instincts of the nomads drove them to seek control of these disputed regions which, while frequently a transit zone for their movements and migrations, nevertheless lacked the natural resources needed by their specialized economy born of and for the steppes. But their lurking presence constituted a tremendous threat to all the sedentary powers in and around Central Asia. In any given place, that threat might take the form of an improvised incursion, of bargaining, outbreaks of destructive violence, precarious alliances, of shrewd playing for time when the sedentary peoples were at odds among themselves, or ruthless, decisive intervention whenever the moment seemed ripe. The menace only rarely disappeared, either because of internal convulsions or successful campaigns conducted by the sedentary peoples, who were constantly seeking to extend the areas under cultivation; but even so it reappeared sooner or later, with the influx of the same or different races. A great deal of ancient Chinese poetry was inspired by the hard life of the garrisons stationed along the frontier to ward off the nomad threat. The poets, whose testimony is supported by historical accounts and written records, sing the vicissitudes of that relentless conflict and lament it as a perpetual curse. For the petty kingdoms of the Tarīm basin, which did not hesitate to confer on their military leaders the proud title of "Scourge of the Barbarians," the nomad incursions, though often checked by intelligent policy, were really a deadly menace, blighting the life of entire generations. Elsewhere, all over Central Asia, the indigenous peoples longed to throw off the yoke of foreign powers, whether imposed by sedentary Chinese, Tibetan mountaineers, or Arab horsemen.

In consequence, the civilizations of Central Asia were all deeply involved in the various forms of religious expansion whose repercussions were felt even in their economic structure, and which greatly favoured the diffusion of vital currents of art and thought, more particularly those from India and Iran, though mingled with others of different kind and source. The religious manifestations of Central Asia constitute in fact some of the most interesting of the whole continent and are at least as significant as its economic importance, since every religious belief acquired an intense reality in the eyes of the faithful, inspiring ineffable hopes and affording their sole support to the tormented souls that humbled themselves before the divinity in a supreme aspiration towards peace. It is not easy to reconstruct the psychological attitude, the vision of life, peculiar to the

sedentary peoples of Central Asia, even if some of its aspects may be defined with reasonable accuracy. Through all their keen enjoyment of sensual pleasures, their eager desire for wealth, their love of ostentation and highly refined elegance, combined at times with artistic interests of the most varied kinds, from music to dancing and painting, there ran a deep vein of rankling dissatisfaction that gave rise to violent spiritual crises among nobles, merchants and military men alike, who would abandon everything in order to dedicate themselves to the religious life. The thirst for pleasure and wealth and the thirst for serenity here went hand in hand, all born of a subtle diffused anxiety, a feeling of uncertainty revealed only in the most evanescent signs.

All the cultures of Central Asia bear the impress of the great caravan routes. These were not simply vital trade routes for the traffic in silk and gold, in glass, in carved gems and iron. Also to be seen passing along them were pilgrims from China and Korea on their way to the holy places of Buddhist legend, as well as missionaries from India and Iran eager to carry the Good Law to the remotest peoples of Asia. History and economics, even the unchanging laws of climate and environment which still make their impact felt in the common life of the Asiatic peoples, and their age-old lust for glory and power appear to have been mitigated through contact with the intense faith of these men who brought serenity and hope to the garrisons kept in a state of perpetual alarm, to towns uncertain of the future and haunted by the nightmare of invasion. And it was not Buddhism alone that followed in the wake of the caravans; for different reasons and with varying fortunes, other religious currents like Nestorian Christianity and Manichaeism moved across Central Asia to the conquest of the Far East, and left behind them not a few traces in the pictorial art of the region.

The intensity of commercial traffic and of the resulting cultural exchanges was due not only to the peculiar geographical position of Central Asia, but also to important historical events that led to political, cultural and economic unification both in the Far East and in the Mediterranean world. The two vast empires of China and Rome thus came into existence, creating two enormous markets capable of attracting the products of every part of Eurasia—markets capable, too, of influencing each other to a slight extent. The network of caravan routes across Central Asia accordingly attained its highest development from the second half of the first century B.C. onwards, with the increase of caravan traffic, supplemented but never replaced by the maritime traffic which developed on the monsoon routes and which, taking advantage of the caravan trade and the ports of India, offered a means of by-passing the Iranian plateau which, owing to political conditions, threatened to become an insurmountable barrier between east and west.

The two great arcs formed by the caravan route in Central Asia proper linked up the oasis towns strung out along the northern and southern edges of the Taklamakan Desert; the two arcs were reunited in a single route at Tun-huang in Chinese territory (to the east of the desert) and at Kašgar close to the Pamirs (to the west of it). All these oasis towns, of the greatest importance alike in their historical, religious and artistic aspects, were thus directly connected with each other. The southern track, skirting the

foothills of the Altin-tāgh, was chiefly used in the first centuries of our era; it went by way of Yarkand (So-chü in Chinese), Khotan, Keriya (Chü-mi), Niya (Ching-chüeh), Čerčen (Shan-shan) and Mirān. The main centres on the northern track were Kašgar (Su-lē), Uč Turfān (Wen-su), Aqsu (Ku-mo), Kuča (Ch'iu-tzu), and Agni or Qarāšāhr (Yen-ch'i), together with Turfān (Kao-ch'ang) and Qōmul (Ha-mi) on a branch road. The great Silk Road ran westwards beyond Kašgar; it crossed Ferghāna and Sogdiana and continued through Chorasmia and northern Iran, branching off to the south towards present-day Afghanistan and the natural gateways to India. Secondary routes, cross-tracks, branch roads and occasional transit zones went to complete a network extending westwards as far as the confines of Syria and Asia Minor, joining up with the road systems of India and Iran, and turning north towards the Black Sea and the Urals.

Around the Silk Road there developed a broad zone of transit and intercommunications, exposed however to nomad incursions and therefore requiring to be constantly defended by the sedentary population. In these desert regions, where even the rock, shattered by earthquakes, seems to defy man's constructive efforts, the paucity of natural resources tended to limit the growth of the population and make it dependent on the commercial traffic. Agriculture, though possible only on a limited scale, was developed to the utmost by ingenious systems of artificial irrigation. Also used around the oases, these irrigation canals formed an essential part of the economy of the region watered by the Oxus and the Jaxartes (Syr Darya), where they profoundly modified the nature of the country, whose economy was therefore very different from that of Kashgaria, further to the east.

Although the regions we are considering form a unified whole, not only geographically but historically and culturally, knit together by the caravan routes and trade relations, they can be divided into two different zones. The western zone, today Russian Turkestan, appears to have consisted of small feudal kingdoms which had behind them the experience of ancient cultures and civilizations deeply influenced by the inter-penetration of the nomad world and the sedentary Iranians; such cultures as that of the so-called "villages with inhabited walls," which reveals the gradual transition from the pastoral economy of the nomads to a sedentary way of life always based, however, on stock-breeding rather than agriculture. The eastern zone on the other hand, consisting at first of nomad hordes of the Scythian or Sarmatian type exposed to the pressure of other palaeo-Asiatic or Altaic tribes, was historically much more divided. It followed a different evolution corresponding to the ethnic structure of its population, which included a large proportion of non-Iranian, Indo-European stocks; an evolution affected, moreover, by a variety of influences, from the classical west, China, Iran and India.

The body of paintings so far discovered make it clear that the western part of Central Asia, though to some extent exposed to the religious currents of Buddhist India, was closely linked with Iran, and also with the Hellenized world and the non-Buddhist parts of India. It only remains to determine whether this link—evidenced by literary sources and a thousand points in common as regards religion, institutions, manners and taste—stemmed from Iran itself or whether, as seems more probable, this "outer"

Iranian world of west-central Asia did not in fact itself influence the cultural and artistic evolution of Iran proper; and if so, to what extent. For while in the art centres of Chinese Sinkiang the Iranian element is a reflection of trends which can be dated and localized, in outer Iran we seem to find the antecedents of enduring traditions that were to take definitive form in the brilliant civilization of Islamic Iran. And in the field of pictorial art it is precisely here, in outer Iran, in the style of the later paintings of Pjandžikent, that we find the immediate prelude to the great Islamic art of Iran proper.

But on the whole all the civilizations of Central Asia are eclectic in character. They took over and recast, with great success, the art forms of the great sedentary civilizations around them: those of the semi-classical cultures of the East, of Iran, of Indo-Greek and Indo-Scythian art, of China, of Gupta India. All these borrowings enter into the cultural evolution of the different zones of Central Asia, varying only in their extent and intensity in a scale of values which extends from minute reminiscences of detail to essential concepts of style and iconography. While in the western zone there was an absolute predominance of Iranian elements, so that it may properly be described as an outer Iranian area, Chinese influence in the figurative arts was confined to the regions dominated by the expansion of the T'ang empire. The impact of China was naturally most intense in the easternmost zones, those nearest to the territory of the empire, and it was brought to bear on Turkish painting, which however, for various religious reasons, also reveals an Iranian component that cannot be ignored. The classical contribution, whether direct or transmitted by Greco-Iranian currents from Parthian Iran and North-West India, made itself felt chiefly at an early stage, although stylistic and iconographic features of classical inspiration persisted for a long time, owing in large part to the spread of Buddhism and the trade with the Roman West.

As for the part played by India, it was unquestionably of considerable importance, increasing as the Gupta empire gained in power and prestige. Gupta influence had to contend, however, with that of Sassanian Iran, and it was the latter that subsequently prevailed, especially in painting. Localized particularly in centres on the northern caravan route from Tumšuq to Kučā, from Aqsu to Qarāšāhr, Gupta influence made itself felt also in Khotan and left traces, much slighter though not negligible, in the art of Sogdiana and Chorasmia.

This eclecticism is in keeping with the essential unity of Central Asia. Though the whole region was split up into a multitude of small local powers, its underlying homogeneity is revealed in many ways: in costume, the social position of women, funeral rites, military organization, and economic, cultural and aesthetic aspects. The effects of internal fragmentation were greatly outweighed by the historical constants that determined the evolution of Central Asia: the continual irruptions of the nomad hordes and the almost unceasing pressure exerted by the great sedentary powers in their efforts to gain control of the Silk Road and its profitable traffic. The whole southern portion of Central Asia was in fact a zone of interpenetration between nomads and sedentary peoples, between the different civilizations of Europe and Asia, between different racial

groups, and between the very centres that flourished there. And even this interplay of contending forces made for unity by bringing the different local cultures into closer contact with each other.

To this can be added another unifying factor: linguistic conventions which, arrived at for commercial purposes, led to the rise of a lingua franca—Khotanese (Saka-Khotanese) to begin with. This may have been one of the results of that unitary cultural phase defined by S. Kiselev as "Hunnic-Sarmatian," which saw the creation of an almost homogeneous cultural belt arising out of the contacts between several different peoples: the Hsiung-nu (really distinct from the Huns), the Sakas (Scythians) and Sarmatian tribes (like the Wu-sun, perhaps the Ἄσιοι of classical sources). The use of Khotanese declined, however, with the political decay of the centres it had sprung from, and Sogdian became the lingua franca of the Central Asian traders. The richness of Sogdian literature, the wide diffusion of the language, and the many borrowings made from its alphabet, all suggest that a vast influence was exercised on the whole southern part of Central Asia by Sogdian culture, which must have been one of the essential components of the mercantile civilizations of Central Asia. This undeniable commercial and linguistic predominance does not, however, appear to have had any particular influence on the figurative arts (with the exception of the so-called "style without development" of Kučā), though a few stylistic and iconographic features may have been of Sogdian rather than Sassanian inspiration.

Such, then, is the setting and background of the works of art we propose to study in the following pages. Painting, as it happens, is perhaps the richest and most varied of the arts of Central Asia, and it is the one which, together with literature, best reflects the secret aspirations of peoples who, however remote and alien they may seem in many ways, are yet very close in spiritual outlook and artistic expression to our own medieval world. Indeed, the analogies of style and iconography are really so extraordinary that they have aroused curiosity and interest well beyond the narrow circles of specialists and enthusiastic amateurs.

In the foregoing outline it seemed desirable to lay emphasis on the constants in the historical development and the essential unity of the milieu itself, so that the reader may understand at the outset why it is possible to speak of Central Asian painting as an entity, broken up though it was among different centres and a multiplicity of currents, all however interrelated. Even the slow Turkization of the region failed to produce any real break of continuity in its cultural and artistic development, for the Turkish tribes who replaced a large part of the original Indo-European population became the heirs and continuators of its civilization. That civilization was only to be wiped out by the Islamic penetration and the resulting disturbance of the political equilibrium of Asia at the beginning of the second millennium of our era.

In conclusion, it may be well to stress the fact that Central Asia was not merely a meeting place of many different civilizations. Its own works of art, however composite, have an indisputable originality, and it was probably less affected by foreign influences than might be supposed. For stylistic currents emanating from Central Asia itself were

not only instrumental in shaping certain Indo-Iranian trends of North-West India and Afghanistan which may be considered the southernmost offshoot of Central Asian art; they also reacted on the artistic evolution of Kashmir, on much of the ancient art of Tibet (particularly painting), and even on Chinese painting of Buddhist inspiration. The extent of this influence is enough to demonstrate beyond any doubt the intrinsic significance and the vigour of Central Asian art. In view of the vast repercussions of the problems it raised, the novelty of the aesthetic principles it obeyed, and a whole series of striking correspondences with the classical, Byzantine and medieval art of the west, it appears today as one of the most interesting of all the forms of figurative art produced in the eastern world.

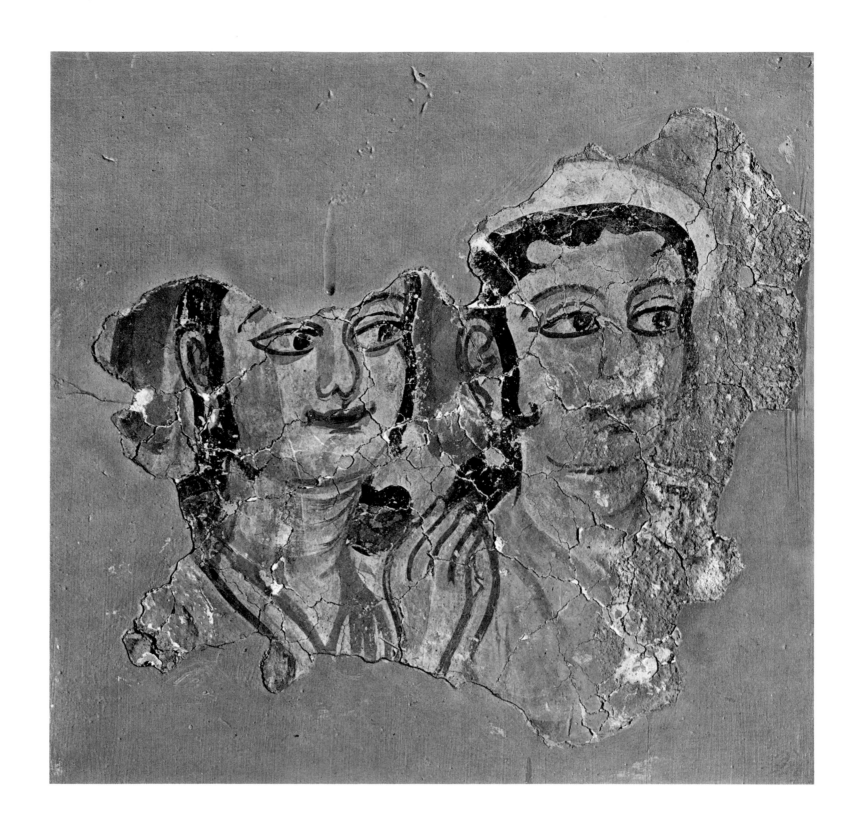

Heads of Two Worshippers. Wall Painting from Mirān. Second Half of the Third Century A.D. (Width 8″)
M. III 0019, Collection of the National Museum, New Delhi.

The Beginnings of Painting in Central Asia

Mirān

1

ALTHOUGH it is rarely possible in Central Asia to discern any direct and immediate connection between the figurative arts and political changes, painting, like all the arts, felt the effects of historical events—invasions and conquests—which were continually modifying the political map of the region. The relative scarcity of documentary evidence, the serious gaps in our knowledge, the difficulty of interpreting what data we have, all no doubt go to create the impression of an ever-changing pattern. But it must not be forgotten that, while ethnic and political conflicts often took a violent turn and upset the equilibrium of the forces confronting each other in Central Asia, there is no indication that they ever resulted in any really revolutionary changes or sharp and decisive breaks of continuity—except in the case of the Arab conquest, which led to Islamization of the region. The economic importance of Central Asia, its immemorial ways of life and the unchanging social fabric of the civilizations that flourished there, a whole complex of local factors bound up with the international spirit characteristic of traders and merchants, contributed to rule out the possibility of any breaks or sudden changes in the local culture.

In this world, richly diversified yet united by innumerable links, what counted far more than invasions, conflicts and traditional alliances was the impact of powerful historical and cultural forces for ever at work in large parts of Eurasia, and having their repercussions on the iconography and style of its art. The fact is that the different phases in the evolution of art in Central Asia are nearly always associated with the predominance of one particular foreign element. It is religious factors above all that determined the cultural features of the region, and the very traditionalism of religious thought, together with the great differences in the cultural level of the nomad hordes that swept over Central Asia periodically, combined to make the development of the figurative arts relatively slow.

In this and the following chapters, therefore, we shall try to trace the unifying as well as the differentiating factors discernible in the art centres and schools, in the successive phases and trends of local painting, and relate them whenever possible to the historical events that go with them. We shall at the same time try to define, as far as painting is concerned, the nature and the limits of that Central Asian unity which we mentioned

in our Introduction. For that unity does not preclude regional or local variations in taste and in style, sometimes far reaching. Nor does the very gradual development of the figurative arts prevent us from discerning a succession of distinct phases.

Central Asia in fact, as the recent discoveries of Soviet archaeologists have made increasingly clear, offers an extraordinary variety of pictorial works of art within the limits of a cultural unity in a state of slow evolution. All these interrelated works were affected in one way or another by the impact of the historical forces already mentioned, by commercial and cultural exchanges, by various factors inherent in an ethnic and social diversity made strikingly evident by the many different languages spoken in Central Asia and the differences in institutions from one state to another.

The first phase of painting in Central Asia is clearly of classical inspiration, though it has an Iranian element whose importance is difficult to determine. Thus in spite of the gaps in our documentation it can be maintained that during the third and fourth centuries A.D. the whole of Central Asia formed a peripheral area within the Greco-Roman sphere of influence at least to the same extent as, perhaps to a greater extent than, the other non-Mediterranean descendants of Hellenism. This classical background, which went to shape the whole future evolution of Central Asian art, was due to the influence emanating from the semi-classical school of Gandhāra that flourished in North-West India and Afghanistan between the first and fifth centuries A.D. The whole group of wall paintings discovered at Mirān on the southern caravan route may be considered a product of the Gandhāra school. Directly or indirectly, that school accounts for much of the iconography and certain points of style peculiar to the earliest wall paintings at Tun-huang, on the easternmost confines of the region; some of these iconographic and stylistic features were later taken over by Chinese art. That there was a considerable Hellenistic influence is likewise shown by the more or less contemporary Kushano-Afrigid paintings of Chorasmia, which depend partly, however, on different sources of inspiration connected apparently with the Romano-Sarmatian schools of South Russia as well as with Gandhāra.

This diffusion of classicizing trends was to a large extent bound up with the eastward spread of Buddhism along the Silk Road, though it is difficult to tell exactly what causes brought it about. These trends took effect after the conquest of the entire Tarīm basin by the Later Han dynasty of China (23-220 A.D.), and after the disappearance of the administrative organization introduced by the Hans and lasting until about 170 A.D. They date to the period when the oasis states, though in fact completely independent, still recognized *de jure* the sovereignty of the Northern dynasties of China. The influx of these trends, moreover, seems to have taken place at the time when the Kushan empire was dominant in the Gandhāra area; at the time, that is, when the Kushans, or those of their successors who had survived the grave crisis of the third century, were looking with interest towards China—not only for commercial reasons but also under stress of increasing pressure from Iran. Now, too, the power of the great Shahs of Chorasmia (third-fourth centuries A.D.) was being consolidated, and all Central Asia seemed to regard the composite culture of the Kushan empire, with its semi-classical

inspiration, as the expression of a kindred civilization able to counterbalance that of Sassanian Iran. This being so, the art of Mirān may be interpreted as an outpost of Gandhāran art, the result of an artistic diaspora caused by the Sassanian invasion; or it may denote a renewal of contact between the peoples of Central Asia and the remnants of the Kushan empire.

Unfortunately the date of the Mirān wall paintings cannot be fixed with any precision, though some clues are provided by the writing of the Kharoṣṭhī inscriptions. One of them, on the leg of an elephant in the Viśvantara Jātaka scenes (Shrine M. V), gives us the painter's name: Tita, perhaps a Prakrit form of Titus, which would suggest an artist of western origin. In the light of these inscriptions, Mirān appears to be roughly contemporary with Lou-lan, Niya and Endere. Sir Aurel Stein has pointed out that practically all the remains of the site—which he identified with the ancient Yü-ni of the Chinese texts, while Pelliot believed it to be the Han colony of I-hsin or I-hsün—are of the same period as the ruins of Lou-lan, with the exception of the Tibetan fort (M. I) and the Chinese cemetery of the Han period. Mirān would thus date to the third or fourth century A.D., which agrees with the palaeographic evidence of the inscriptions. Stein surmised that Mirān, for reasons unknown, was abandoned at the same time that Lou-lan, for equally mysterious reasons, ceased to be occupied. His opinion is borne out by similarities in the material culture of the two sites, and by the presence of decorative motifs common to both, such as the modified Persepolitan capital, derived from Gandhāra.

The technique of the Mirān paintings provides no clue to their dating, which can only be estimated on the basis of iconographic and stylistic criteria. They are all by the same hand, or anyhow by a single group of itinerant artists (a master and his pupils, perhaps). They contain unmistakable reminiscences of classical art, not only in the treatment of drapery but also in the skilful use of chiaroscuro, obtained by means of a light clear coat of paint laid in over the highlights—a method previously adopted in some Hellenistic paintings and mosaics, and not unknown in Byzantine art and the Damascus mosaics. The large eyes may be of semi-classical derivation, though this is by Illustration page 18 no means certain, for the affinities with Iranian art of this or later periods must also be borne in mind. On the other hand, the paratactic composition of certain scenes, the motif of garlands upheld by cupids and framing other figures, and the handling of drapery unquestionably stem from Gandhāra, and are therefore classical in origin. Altogether, on the strength of their style and their Buddhist content, which does not exclude symbolic compositions and motifs of the Kushano-Iranian type, the wall decorations of Mirān can be considered to form the most extensive group of Gandhāran paintings still in existence—preserved, oddly enough, far outside the Gandhāra school's normal area of diffusion. Indeed, in view of some highly significant features of their style and iconography, these paintings can be linked up with a particular trend of Gandhāran art, rich in western elements brilliantly recast.

The iconographic analogy between the fragment showing the Buddha attended Illustration page 23 by six monks (M. III 003) and the Gandhāra relief showing the Buddha accompanied by Vajrapāṇi (Staatliche Museen, Berlin) points undoubtedly to a specific source.

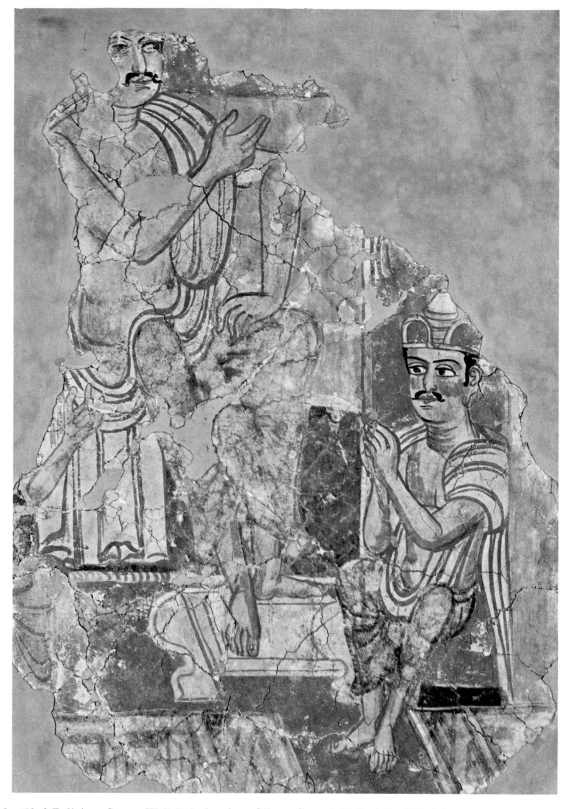

Unidentified Religious Scene. Wall Painting from Mirān. Second Half of the Third Century A.D. (Height c. 29″)
M. III 002, Collection of the National Museum, New Delhi.

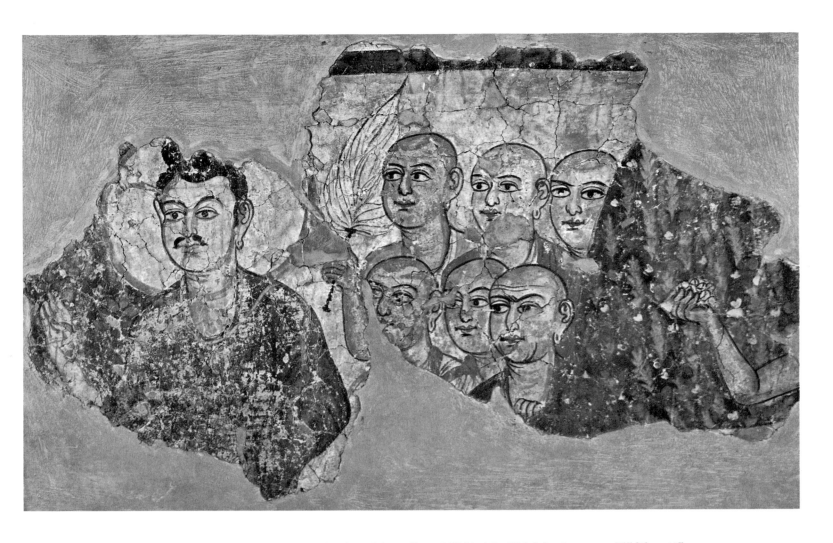

The Buddha attended by Six Monks. Wall Painting from Mirān. Second Half of the Third Century A.D. (Width 39½")
M. III 003, Collection of the National Museum, New Delhi.

The huge, badly damaged *uṣṇiṣa* of the Buddha at Mirān, with the structure of its face Illustration above
and eyes, the drooping moustache, the drapery, the halo surrounded by an inscribed
circle, and the leaf-shaped fan held by a monk (exactly the same as the fan held by the
Vajrapāṇi of the relief), together constitute evidence of the most irrefutable kind.

But the iconographic link between the Mirān paintings and the Gandhāra sculptures
is not confined to the Berlin relief alone; it extends to a whole series of works from the
north-eastern part of the Gandhāra region (Ysufzai) which, by way of a road across
the valley of the Swat, is directly connected with the southern track of the Silk Road.
Some of these works, which belonged to the collection of the Corps of Guides at Hoti
Mardan, appear to come from a single monument, judging by the camber and dimensions
of the narrative panels. These may have been moulded by the same hand and it would be
tempting to identify it with that of Tita of Mirān. That might well be done in view

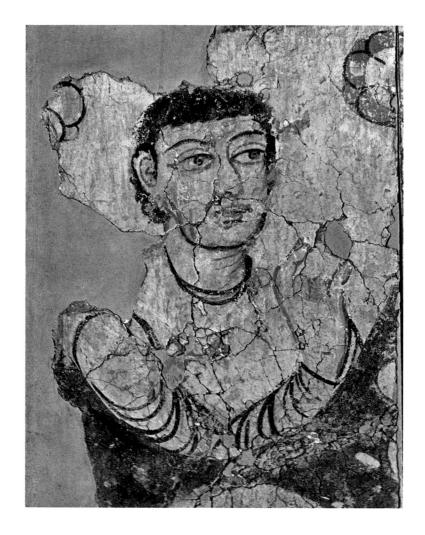

Fresco with Garlands and Figures, detail. From Shrine V, Mirān. Second Half of the Third Century A.D.
(Height c. 17½″) Collection of the National Museum, New Delhi.

of a whole series of points of style, and iconographic analogies confirmed by such things as the characterization of the persons, which is so very special although not at variance with the main rules of the tradition. Moreover, there is in these Gandhāra compositions a treatment of perspective and volume aiming at illusory, *trompe-l'œil* effects, with minutely calculated intersections of planes, receding lines, arched surfaces and incised carving, so that the composition presented to the eyes of the faithful as they circulate appears completely satisfying. It is a deliberate illusion, or rather an effect of verisimilitude produced by distortion (anamorphosis), suggested by the rite of *pradakṣiṇā* and harmonized with the movements the onlookers must make in going round the stūpa. There appear to be precedents for this at Bhārhūt, but Gandhāra certainly profited by western experience, pre-Hellenistic and Hellenistic, in matters of perspective and optical effects, modified and accentuated by local talents and needs.

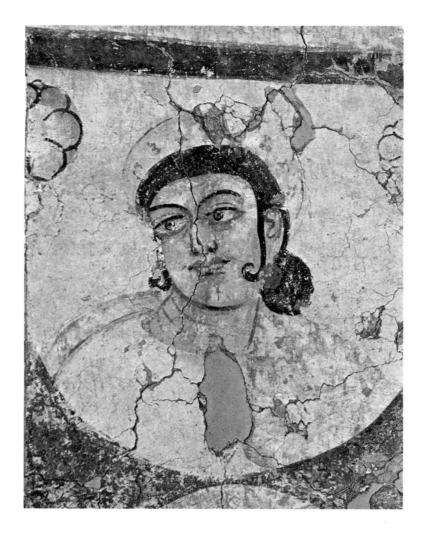

Fresco with Garlands and Figures, detail. From Shrine V, Mirān. Second Half of the Third Century A.D.
(Height c. 17½") Collection of the National Museum, New Delhi.

The relation between the Mirān pictures and these creations thus becomes of much greater significance than was anticipated. One fragment from Mirān, for example (M. III 002), depicts a figure seated on a throne, presumably a sacred personage, judging by the smaller size of the figure in front of him, who however is wearing the characteristic head-dress of kings and princes. The perspective effects here closely resemble those employed in the Gandhāra carvings described above. To the perfect coherence of the lines receding along the geometric structure deliberately introduced into the composition, corresponds the coherence of the chiaroscuro, which suggests an unseen source of light on the upper right. The oblique shaft of light falling on the receding lines and the bodies accentuates the shallow depth of the picture space and brings out the relief of the leading figure. The very same effect is achieved, although by different means, in some of the more static of the Gandhāra sculptures. In spite, therefore, of the different methods adopted, it can

Illustration page 22

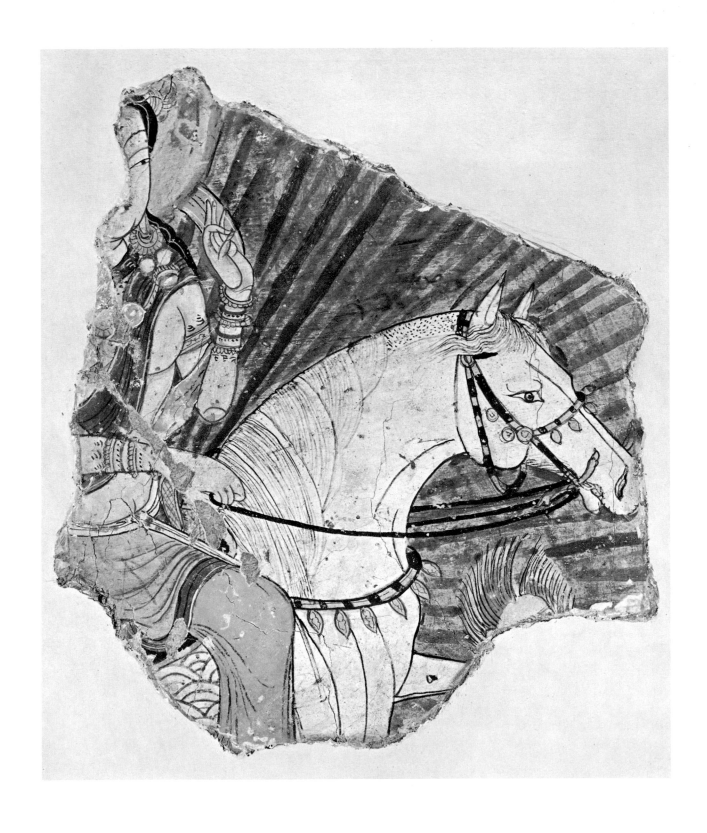

The Future Buddha renouncing the World. Wall Painting from Qočo. Ninth Century. (Height 10¾″)
I B 4426, Indische Kunstabteilung, Staatliche Museen, Berlin.

be said that there is an analogous striving after illusionism. On the other hand, the function of light playing on the colours in the Mirān composition is clearly indicated by the twofold perpective of the stool on which the feet of the principal figure are resting —the effect being produced by the interplay of line and colour. Into the vertical outline of the stool, shown in dabs of colour, is obliquely inserted the rectangle of the supporting plane, traced out in red, which fits into the geometric pattern on which the ascending perspective is based. This treatment was evidently dictated by the artist's predilection for a composition in which, by various devices, the perspective effects obtainable from light and colour could be given full play and put to the service of illusionism. In the fragment previously described, it is easy to see that the eyes of the Buddha are intended to gaze straight into those of the spectator, following him whichever way he moves, for the eyes are shown frontally while the rest of the face is in three-quarter view. The illusion is heightened by the contrast with the expression of the six monks, whose eyes all converge on the master from different angles.

Illustration page 22

Illustration page 23

Painting in Central Asia, therefore, begins with a group of works remarkable for the skill with which perspective and illusionist effects are handled. They afford an interesting basis for its later development which, even if it employs different procedures, very often presupposes a more or less profound knowledge of the experiments in anamorphosis made by the sculptors of the Gandhāra school and translated into pictorial terms at Mirān.

As we have seen, the stylistic evidence available makes it possible to correlate the Mirān paintings with a particular trend—presumably a belated one—of Gandhāran stone-carving, which is known to be earlier in date; and this despite the fact that some features at Mirān (e.g. the neutral background, in certain scenes, with floral decorations of rosettes) are Central Asian rather than Gandhāran. This correlation enables us to arrive at a tentative dating which is borne out by small details both in the extant paintings and in those which, though now destroyed, can still be studied in Stein's photographs; such details, for example, as the loop-holes shaped like arrow-heads on the walls of the palace of Viśvantara and the partially frontal view of the prince's chariot. Further indications as to dating can be inferred from the surviving frieze with garlands: the costume and build of the female figure (of the Gandhāran type with Palmyrene reminiscences), the obviously Iranian attitude of the semi-classical figure beside her, and the unnatural way the arm is attached to the shoulder. These peculiarities, together with the hair style of some of the cupids supporting the garlands, the Parthian head-dress of others, and the classical Roman structure of the young man's figure (M. V, VI) suggest a date for the Mirān paintings somewhere in the second half of the third century A.D. Any date much later than this seems highly improbable.

Illustrations pages 24-25

Be that as it may, the Mirān paintings vouch for the introduction into Central Asia of perspective techniques of sufficient complexity and refinement to leave their mark very distinctly on the subsequent evolution of painting, constituting indeed a far from negligible factor in the phases immediately following. Effects of colour and light, here used technically in the service of a complicated system of optical illusion, were to be

developed in yet other ways in the art of Central Asia. They became in time the very essence of an aesthetic attitude not unlike that of our own Middle Ages in their treatment of light and colour. As we shall see, this conception of light and colour answered to the symbolic values and mystical speculations of Indian and Iranian origin which entered so largely into Buddhist thought.

But before dealing with these complex problems of light and colour values, which derive only collaterally from Mirān, it may be well to call attention to other, very different developments arising from that earliest group of paintings. In works of that initial phase in Central Asia, the classical element, whatever the extent to which it was transmitted by way of Iran and Gandhāra, ensured the absolute pre-eminence of the human figure. Favoured by the partiality of Buddhist art for edifying narrative themes, this pre-eminence was long maintained and does not disappear even when the scene changes from the quasi-human level in the story of the Buddha's lives to the more complex plane of Paradise and the great miracles. Moreover the Iranian element, so evident in subsequent phases, contributed to maintain the primacy of the human figure, which held its ground even under the impact of Chinese influences. Inherent in Buddhist thought and inseparable from the edifying tendency of the art it inspired, that primacy remained a constant, unifying characteristic, even in the western area of Central Asia, where it was sustained by the Iranian tradition and its figurative values. Only in some of the fantastic compositions at Tun-huang is the emphasis on the human figure attenuated, giving place to a different scale of values in which equal importance is attached to setting and landscape, animal forms and fantastic figures. But the general outlook in Central Asia was such that it easily counteracted the Chinese tendency to reduce the role of the human figure—a tendency, anyhow, that was gradually weakened both by the Buddhist figurative tradition, now fully established even in local art, and by the so-called realism of T'ang art with its special interest in the human form. It is for these reasons that even in some works of Chinese inspiration in the latest phase at Kučā

Illustration page 26 (e.g. the Qumtura wall paintings) and in Sino-Iranian works of the Uighur period at Turfān, the human figure remains absolutely preponderant, whatever the semantic value attaching to it.

In all the art of Central Asia the proportions given to figures have a symbolic value, the leading figure invariably being larger than the others. This symbolism is sanctioned by the speculations contained in texts dealing with the stature and aspect of the Buddha. An Iranian element of the same kind also played a part in establishing this practice, and it is easy to see that the ornamental value attributed in India to the human form and especially to the couple (mithunā) is appreciably diminished in Central Asia owing to a completely different sensibility and a much stronger mystical urge whose foundations were laid long before in the regions subject to Indo-Iranian influence.

The subsequent stages in the development of painting in Central Asia largely depend, we may affirm, on those particular elements of classical influence already exploited at Mirān and by no means neglected, though apparently less conspicuous, in the art of Chorasmia. The vast series of wall paintings which constitute the artistic wealth of

Central Asia thus begins with these semi-classical works which are its foundation. Owing, however, to the very predominance of this classicizing element, the painting of Central Asia as a whole takes its place in the tradition of Indian religious art. Nor is it a mere accident that the Indian technical handbooks *(śilpa-śāstra)* are devoted almost entirely to wall painting, giving practical directions as to the execution. And the Mirān paintings, like those of Chorasmia, clearly belong to a semi-industrialized art which deliberately availed itself of such technical procedures as would ease and simplify the painter's task, cartoons and models being used to duplicate scenes, perhaps by means of the so-called Indian double design or simply by pouncing.

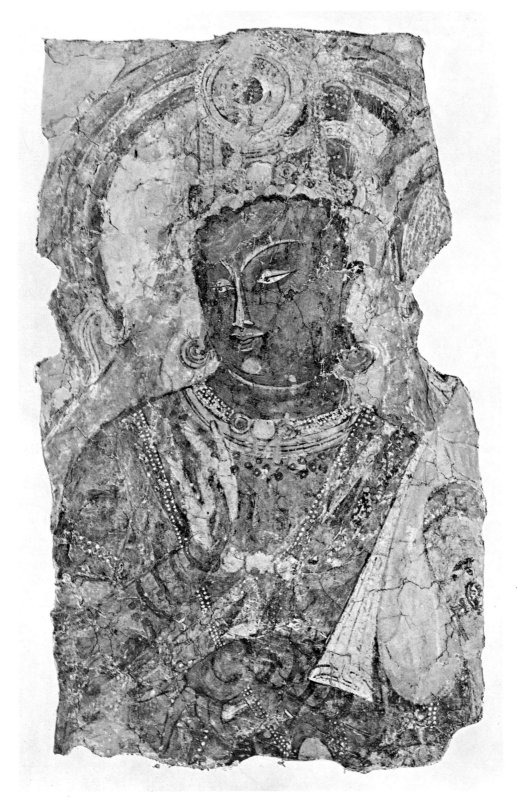

Worshipper (God or King). Wall Painting from the Cave of the Coffered Ceiling, Qïzïl. About 650.
(23¾ × 13⅞″) I B 8900, Indische Kunstabteilung, Staatliche Museen, Berlin.

The Aesthetics of Light

2

THE use of chiaroscuro at Mirān was followed up elsewhere. Treated in the Chinese manner, with contours and relief indicated by broad heavy strokes (which, owing to the fading of the colours, are today little more than blackish streaks), chiaroscuro occurs in many of the oldest of the wall paintings of Tun-huang, including those in Caves 272 and 275 (according to the numbering of the Tun-huang Institute). As A. C. Soper has pointed out, the paintings in these two caves probably belong to the Liang period, which would date them to the first half of the fifth century A.D. At all events, this technique persisted for several decades and became especially frequent in the late fifth and early sixth century, with the addition of those light-coloured accents bringing out highlights which were a favourite device of the Mirān painter.

Illustration page 125

A similar technique is found at Qïzïl, near Kuča, in what is called the second style. On a surviving fragment depicting either a miracle or a scene of worship, the figure of a worshipper, perhaps a *deva* (divinity) or a *rāja* (a legendary sovereign), is treated in this way. This figure, which comes from a sanctuary hewn out of the rock, known as the Cave of the Coffered Ceiling, shows that the use of this illusionist device persisted until the middle of the seventh century. The lessons learned from Mirān had not been lost, and we can see that chiaroscuro was employed at Kuča in exactly the same manner as at Tun-huang. This fact confirms the continuity of the contacts maintained between the different centres of Serindia, as the eastern part of Central Asia is called.

Illustration page 30

The campaign of General Lü Kuang, who in the year 383 A.D. annexed Kuča to the domains of his master Fu Chien, a ruler of the Early Ch'in dynasty (351-394), was undoubtedly an historical event of great significance for those cultural exchanges. For as a result of Lü Kuang's expedition the great Buddhist commentator Kumārijīva was taken to China to carry on there his exegetical and apostolic work, while Lü Kuang himself, on his return to China, proclaimed himself emperor of the Later Liang of Kansu (386-405). Even though Lü Kuang's conquest was no more than an episode, it paved the way to Chinese supremacy, which was maintained under both the Northern Wei and the Sui dynasties—a fact which goes far to explain many similarities of style.

The Qïzïl figure, taken along with countless others, shows an important change in the methods used to get the effects of relief and foreshortening. The face is asymmetrical,

Illustration page 30

as in many Gandhāra figures in stone and stucco, but even though this asymmetry has antecedents at Gandhāra its proportions and technique correspond much more closely to the Indian principles of foreshortening laid down in the handbooks on wall painting, in particular to the principle of *kṣayavṛddhi*, or "increase and decrease." The face of

Illustration page 30

the figure is turned to the left; the receding parts of the face are contracted, the more visible parts enlarged, the former obeying the law of *kṣaya*, the latter that of *vṛddhi*. The two parts, divided by a line passing through the ridge of the nose and the tip of the chin (these being salient features and therefore highlighted), are called in Sanskrit *Kṣayabhāga* and *Vṛddhibhāga*. The Indian terminology, as we see, applies perfectly to this treatment of foreshortening. There is nothing exceptional about it, but the way colour is used to produce effects of bold relief makes it highly interesting. The use of this

Illustration page 33

procedure, without any further experimentation with light, can be traced down to later times, particularly in the Sino-Iranian art of Turfān.

Here, however, we are more concerned with the relations between lighting, relief and foreshortening, which were combined in various complicated ways in the different phases of Central Asian art. Throughout Central Asia in fact, while responding to a variety of aesthetic and figurative influences, painting was dominated by a concern for lighting effects so marked that it can be considered an essential characteristic. We are therefore entitled to speak of a genuine aesthetics of light as such, expressed in many different ways. There was the use of wall paintings, for example, to create within the confines of the cave temple a sense of space filled with an otherworldly light, in contrast with the surrounding gloom; this was a traditional practice also highly developed in India.

Illustration page 34

There was the symbolic use of light in the polychrome nimbi of the divinities (often emphasized by abstract geometric designs) and in the haloes round the heads of the Buddhas which throw the faces into relief by means of colour contrasts. The use of a colour symbolism is evident, but its meaning is not always clear. A symbolic value also attaches to the luminosity of the Buddha's body or the luminous quality of the *hvarənāh* (i.e. the Splendour and Power of divine and human sovereigns) indicated by flames issuing from the shoulders—a formula found all the way from Pjandžikent to Tun-huang. Besides all this, many astral symbols continually recur in every kind of picture.

This constant concern with the rendering of light—evident, too, as we have seen, in the treatment of relief and foreshortening—may perhaps be traced to a twofold source. It is an undeniable fact that Buddhism, drawing in part on ancient Vedic and Brahmanic speculations, laid stress on light not only in its theoretical doctrines and the later Tantric cosmogonies, but also in the art forms which it inspired. Buddhist iconography makes constant use of the nimbus, of the halo, of flames issuing from the shoulders—symbols which are undoubtedly derived from representations of the *hvarənāh* of the Kushan kings and recur in the image of Dīpaṃkara (one of the Buddhas of the Past) and, through Śākyamuni, in the great miracle of Śravastī. These iconographic features underlie the experiments in style and composition which are everywhere apparent in the art of Gandhāra, and whose aim was the development of light values. Light was made to play around the gilt or polychrome image of the Buddha in the moulded arch of a cave or,

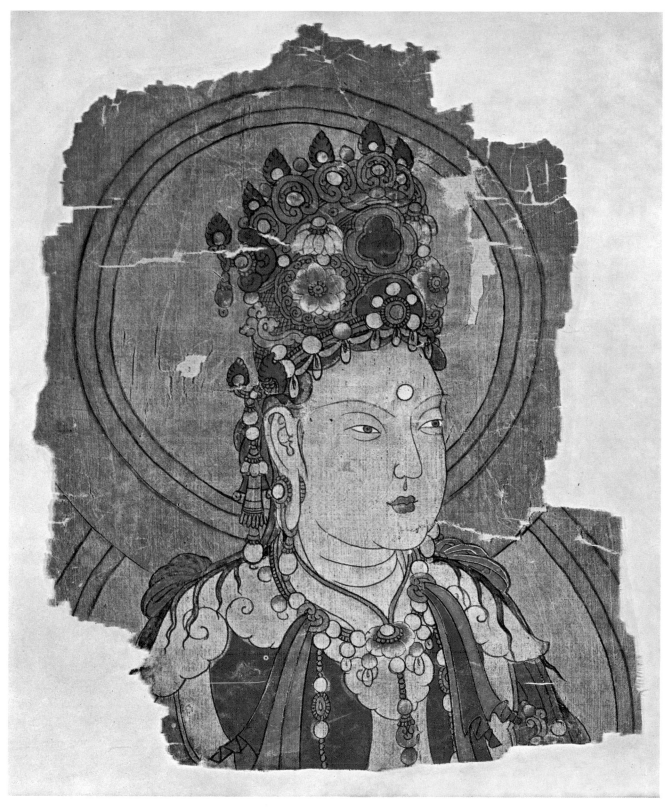

Bodhisattva with an Elaborate Crown. Painting on Silk from Area K of the Ruins of Qočo. Tenth Century. (Width 10″) I B 6166, Indische Kunstabteilung, Staatliche Museen, Berlin.

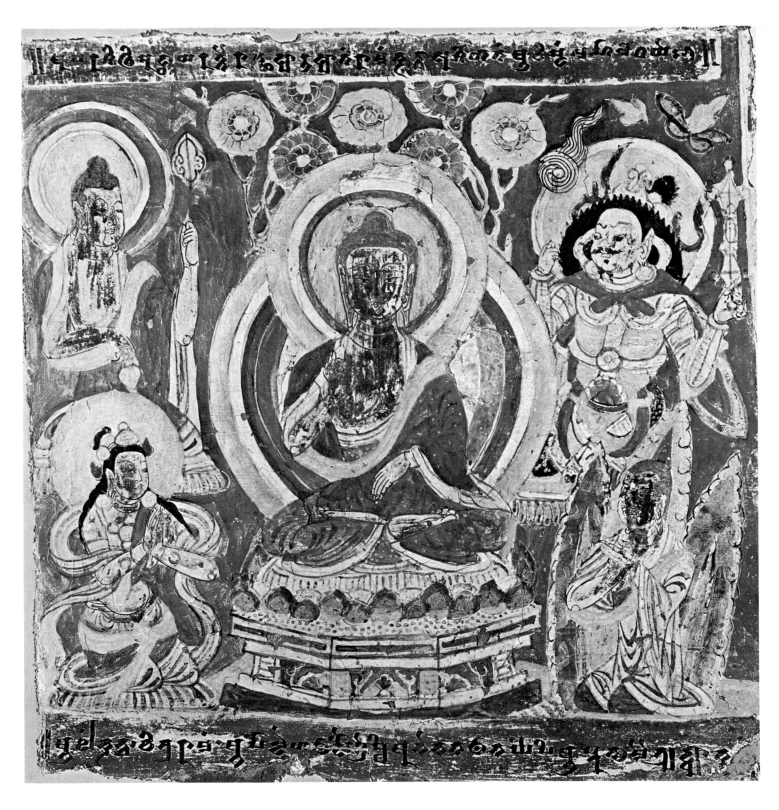

Buddha (Amitābha?) with Halo and Nimbus, worshipped by Three Deities and a Monk. Wall Painting, probably
from the Temples of the Sängim Gorge, near Turfān. Eighth-Ninth Centuries. (Width 18½″)
I B 6871, Indische Kunstabteilung, Staatliche Museen, Berlin.

by means of reflecting surfaces, to emphasize the plastic masses of the surrounding figures. This aesthetics of light is of course not unlike that inspiring a great deal of European medieval art, and the theory behind it, according to S. Taki, was worked out in the texts in precise and comprehensive terms. He sees traces of it in the *Saddharmapuṇḍarīka Sūtra*, the *Suvarnaprabhāsa* and the *Sukhāvatīvyūha*. It is certain, in any case, that Buddhist doctrine led to far-reaching speculations on the subject of light, formulated in these and other texts and further developed under the influence of Iranian religious thought. It was this Iranian element that gave its vitality and appeal to Amitābha-Amitāyus, the supreme Buddha of infinite light and life, hypostasis of the Śākyamuni. The very essence of the Buddha and the Dharma (the Law he preached) may itself be translated into terms of light. It was natural, therefore, that the art of Central Asia, so closely bound up with the various developments of Buddhist thought (Hināyāna, Mahāyāna, Vajrayāna), should be deeply influenced by them and sometimes bear the most striking resemblances to Byzantine and medieval Christian art. The Iranian element that predominated in the western zone was similarly responsive to speculations about light and about the stars, and this symbolism of light may therefore be considered one of the unifying characteristics of all Central Asian art, not of painting alone.

The problem now arises of evaluating the part played in Central Asia by Iranian and Indo-Iranian art currents. Political events in the countries bordering on Central Asia go far to explain the spread of Iranian influence. It was due in part to political expansion eastwards under the Sassanians, favouring the diffusion of their culture; and in part to the successive movements in this region of nomad and sedentary peoples—the mysterious Kidarites (last mentioned in the Chinese imperial chronicles of 447 A.D.), the Juan-juan, the Hephthalites, the T'u-chüeh, while in China itself the nomad dynasty of the T'o-pa Wei, which enjoyed great prestige throughout Serindia, prepared the way for the Sui dynasty (581-617), followed in turn by the T'ang in 618. It is difficult to reconstruct the circumstances in which the Iranian contribution was made, but it seems to have stemmed in more or less equal measure from the nomads of "outer" Iran and from the Sassanian empire of Iran proper.

The recent discovery of wall paintings at Balalik Tepe, near Airtam Termez, has greatly modified traditional opinion in the matter. Here we have a group of works, mainly decorative though symbolic at the same time, which have been dated by L. I. Al'baum to the fifth century and are thus more or less contemporary with the earliest of the Tun-huang paintings. Certain features, such as the ornamental motifs on garments, the crowns with veils and bells as well as the small *kustī* completing the clothing of the figures, are of Sassanian inspiration. They confirm the close relations that existed between this peripheral region and the expanding Sassanian world. Yet the spirit and style of the figures are original and independent. Distinctive of the Balalik Tepe paintings are the many libation scenes; the build of the figures seated Oriental fashion and enveloped in ample robes, so that they form a row of large colour patches; the symbolic proportions of figures (i.e. their size depending on their importance in the scene), which creates a flattened picture space confined to two superimposed planes. In the light of these works,

Illustration page 37

Illustration page 38

the role hitherto attributed to Bāmiyān, as the intermediary between Iran and the Buddhist world of Central Asia, will have to be re-appraised. For the independent style revealed at Balalik Tepe proves that already in the fifth century the western part of Central Asia was following styles and trends of an Iranianizing type either unknown to Sassanian art or as yet undocumented. We may therefore assume that certain trends which developed in the Serindian centres were in reality echoes of East Iranian creations which had been carried eastwards with expanding trade as the states of the west, Sogdiana, Ferghāna and Afrigid Chorasmia, acquired economic predominance.

Bāmiyān, famous for its colossal statues of the Buddha, was a prosperous caravan town on the road from Bactra to Taxila. But it was also a most important religious and monastic centre of Hināyāna Buddhism, which flourished from the late first to the seventh century. Much later it became for a time the capital of a small kingdom.

The art of painting was practised on a large scale at Bāmiyān and it was here, legend says, that Mani received his education in the arts, a fact indicating the great renown of the place at that time. In addition to minor influences, the surviving works reveal a combination of different styles and trends—from Gandhāra, Syria, Iran (especially Sassanian Iran) and Gupta India. Here again, then, classical traditions assimilated by Buddhism have been fused with an Indian strain and a very considerable Iranian element. The latter, chiefly confined at first to decorative motifs (in the third-century paintings), afterwards became pervasive, perhaps under the influence of the small centre of Duḫtar-i-Nuširwān. Owing to the proximity of the Iranian world, and the fact that the political predominance of Sassanian Iran was being increasingly felt there towards the sixth century, it has been assumed that the Bāmiyān paintings are largely a result of the confrontation of Buddhism with Iranian art properly so called. Actually they must have been produced by artist-monks of different schools and different nationalities, in obedience to the rule "a day without work, a day without bread." It may be, too, that a local strain entered into their work, which would suggest that Bāmiyān had a school of its own, despite the great variety of styles and trends resulting from foreign influences.

Possibly Balalik Tepe exerted some influence on Bāmiyān. The Balalik paintings deal exclusively with the human figure, but they abound in meticulous renderings of detail in dress, weapons and libation objects. Neither Bāmiyān nor Duḫtar-i-Nuširwān shows such complete indifference to important accessories like thrones, stools and so forth, which have great symbolic value in Buddhist thought. Yet some of the Bāmiyān compositions, with processions of donors behind a balustrade, before whom the Buddhas in *padmāsana* seem to hover in mid-air, bring to mind the figures at Balalik Tepe (where, however, there is no balustrade). The Byzantinizing images of the Buddha, also found about the same time at Haḍḍā, an ancient centre of late Gandhāra sculpture, are accompanied by friezes of figures clearly Iranian in dress and style, and by compositions closely resembling those of Gupta India, though with a finer feeling for finish in colour and draughtsmanship. At Bāmiyān, too, there are long rows of Buddhas. The cupolas of the rock-cut sanctuaries are covered with Buddha images arranged in contiguous circles (or in hexagons), themselves enclosed in concentric circles; the dome overhead thus

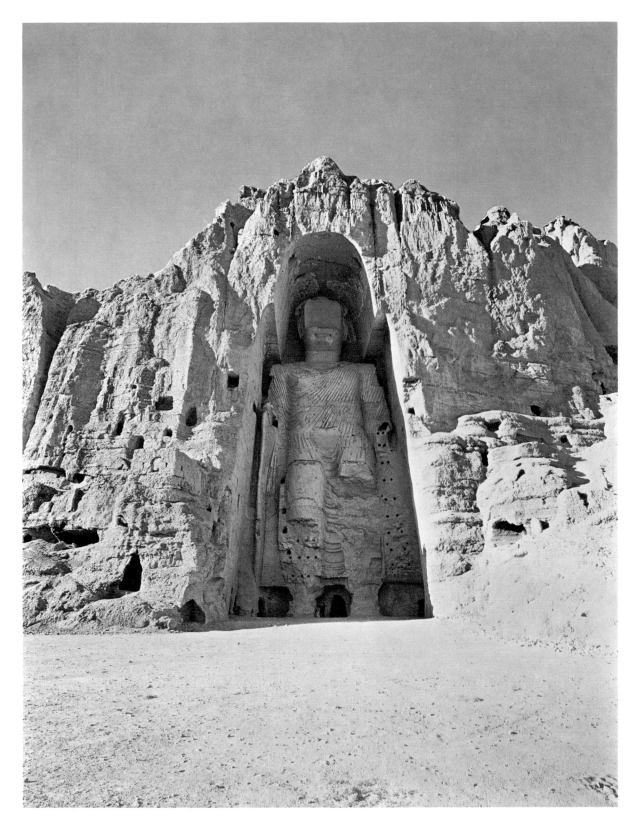

Colossal Statue of the Buddha at Bāmiyān. Fourth-Fifth Centuries. (Height 175 feet)

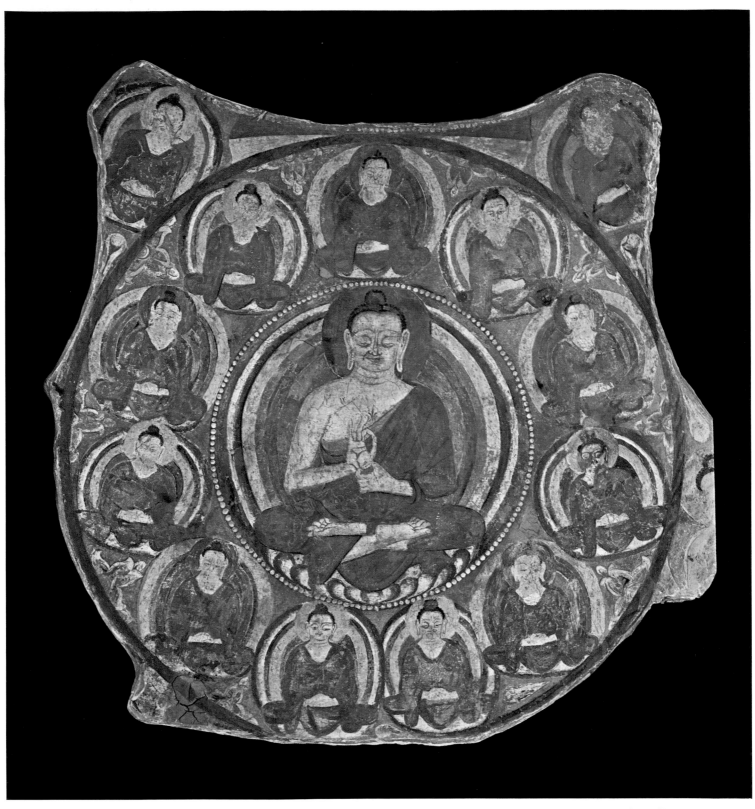

Maṇḍala with the Buddha Preaching, surrounded by Smaller Buddha Figures. Ceiling Painting in a Dome, from Bāmiyān. Fifth-Sixth Centuries. (Diameter 33⅞″) Archaeological Museum, Kabul.

The "Hunter King" with Two Buddhas seated on Lotus Flowers. Wall Painting from the Drum of a Dome at Kakrak. Fifth-Sixth Centuries. (Length 51½") Archaeological Museum, Kabul.

formed a kind of *maṇḍala*, giving a symbolic representation of the sky miraculously filled with innumerable images of the Buddha, luminous and illusory. The same theme also occurs of course in Central Asia; there it is often enriched with flowery arabesques twining round the figures, reflecting that joy in floral decoration common to most of the paintings of Central Asia, but only occasionally to be seen at Bāmiyān.

The paintings of the small neighbouring centre of Kakrak are closely related to those of Bāmiyān, but differ from them in a few significant details. There was a Buddhist monastery at Kakrak, apparently unrecorded in Chinese annals, but of some importance judging by the quality of its surviving works. The painting which adorns the drum of a dome, the so-called "Hunter King," is an outstanding work, remarkable not only for the richness and variety of its colours, but for its lively drawing, intelligent stylization and a sure touch in the refinements of the decorative structure. The main figure, a haloed sovereign wearing a crown ornamented with three crescents, is seated Oriental fashion on a stylized throne. He must represent an historical king deified after his death or, less probably, a divine being in the trappings of earthly royalty, since the diadem with three crescents recurs on certain Ghaznī coins of the Napkī type. The breast-plate, the

Illustration above

age 39 bow he holds in his hands, the arrows sticking in the ground, and the dog (only the forepart showing) all suggest the idea of the hunt and explain the title by which the picture is known. In the centre and on the left, within the framework of a continuous architectural motif of columns and lozenge-shaped pediments of Gandhāran inspiration, Buddha figures with round polychrome haloes are seated on lotus flowers. Enlivened by bright contrasting colours, this composition seems on the whole more harmonious than some comparable scenes at Bāmiyān.

In other works as well, both paintings and sculpture, the art of Kakrak seems more mature and harmonious than that of Bāmiyān, a case in point being the great twenty-three-foot statue of the Buddha, which is placed well in view and not obscured by its rock-cut niche like the Bāmiyān colossus. The paintings of the "Hunter King" group probably date to the sixth century when the renewed influence of fifth-century Gupta India had already been assimilated and fused, more completely than elsewhere, with the steady influx of Iranian currents. We may well ask indeed whether the pictorial experiments thus far made in Central Asia are not reflected at Kakrak, where we find a much more thorough-going stylization, one probably more indebted to the Central Asian art of outer Iran than to the Sassanian world.

Iranian influence, whether exercised directly or transmitted via Sogdiana and Bactria (Balalik Tepe), is still more pronounced in works found in the monastery of Fondukistān. It makes itself felt not only in the clothing and ornaments of the different Illustration page 125 figures (like the sun and moon gods with their complicated symbolism), but most of all in the elongation of the human figure conspicuous in sculpture and painting alike. The closest parallels to this treatment of the human figure are to be found in the wood carvings and wall paintings of Pjandžikent (Styles II and III) and in the frescoes of the Treasure Cave at Qïzïl—the latter in an isolated style undoubtedly influenced by Sogdian art. But even among the Fondukistān paintings, which belong to a later period (probably the seventh century A.D.) and reveal the diffusion of Central Asian styles in an area dominated by the cross-currents of Indian and Iranian art, we find works that are clearly of Indian inspiration, though they are not without some Iranian touches. Illustration page 41 The Blue Lotus (utpala) Maitreya from the entrance to Niche E in the Fondukistān monastery demonstrates how complete the fusion of these styles had become. We need only consider the sinuous attitude of the body derived from Indian models, its elaborate kēyūra (Indian bracelets worn on the upper arm), the enormous ear-rings, and the garment itself. The whole build of the figure is of Indian type, but the fluttering scarves, the realistic handling of draperies, and the long delicate hands are distinctively Iranian. The flat, rounded face with the finely shaped almond eyes is clearly Central Asian, though there is no longer any attempt to render chiaroscuro. Thus the fusion between Iranian and Indian components is complete. The styles of painting worked out in the northern regions have now, however, reacted on and modified the evolution of this composite art born of the encounter of two great civilizations. Although this art has not inaptly been described as Sassano-Gupta, this term takes no account of the highly characteristic features which stem from Central Asia.

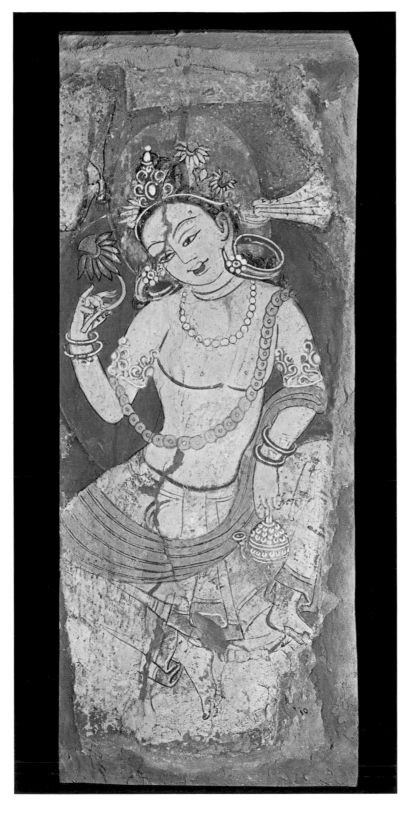

Blue Lotus Maitreya. Wall Painting from Niche E of the Monastery of Fondukistān. Seventh Century.
(Width 9½″) Archaeological Museum, Kabul.

So far we have refrained from evaluating the extent of the Indian contribution. Rooted in the unchanging iconography of Buddhist art, Indian influence, while varying with time and place, always remained fundamental. We can gain a fuller appreciation of it, however, by studying it in relation to the styles and centres which it affected. For the nature of that influence varied considerably, depending on its sources: the semi-classical or semi-Iranian schools of North-West India, like Gandhāra and Mathurā, or the art trends exemplified at Ajantā. It was only in the blossoming time of Gupta art that Indian influence became a homogeneous force with far-reaching effects, though even then the question arises: does Gupta art as a whole have an authentic stylistic unity of its own? Again it may have been the northernmost centres of India, with their independent tendencies, that acted as intermediaries between the figurative art associated with the Gupta empire and Central Asia proper. If such was the case, then once again the Iranian element had insinuated itself imperceptibly, in a thousand different ways, into works that were destined to leave their mark on the art of a world already distinctly Iranianized. But from India as well, true to its ancient traditions, came themes and influences that were easily incorporated in that aesthetics of light considered above, which, though essentially Iranian, found support and fulfilment in the thought and tradition of both Buddhist and Hindu India.

Pjandžikent and the Influence of Sogdiana

3

A^N Iranian strain, originating in Sassanian Iran, runs through all the art of Central Asia. It can be traced in stylistic and iconographic details of every kind: conventional attitudes and gestures of certain types of figures; the stylization of mountain scenery peculiar to some of the Tun-huang wall paintings and inspired by Sassanian reliefs; particular symbols and usages pertaining to the Iranian kings. Moreover, the eastward penetration of Manichaeism, partly because of the persecution of its adherents under the Sassanians, increased the influence of Sassanian Iran (even in the figurative arts), although the diffusion of Mani's teachings through Central Asia was very largely due to Sogdian merchants. Finally, with the Arab conquest of Iran and the downfall of the Sassanian empire, Iranian courtiers and noblemen fled to the east in large numbers, with the result that from about the year 670 A.D. onwards the presence of many of these exiles at Kučā and other centres, even at Ch'ang-an, the capital of T'ang China, may have been much more significant in its effect on the arts in this region than is commonly supposed.

As already mentioned, the western part of Central Asia constituting outer Iran had a cultural character of its own and its art forms were handled with distinct originality. This is well illustrated in the great complex of wall paintings brought to light at Pjandžikent, an important commercial and strategic centre in Sogdiana. They testify to the existence of a local school of painting, Iranian in tendency, yet highly individual.

The school of Pjandžikent has affinities with Balalik Tepe, Varakhša and less important centres in Kirghizia and Tadžikistan, thus proving itself to be part of a widespread art movement not wholly confined to Sogdiana. Owing in part to the complexity of the problems involved, the political history of Pjandžikent remains obscure. We do know, however, that the place existed in the fourth century A.D. and reached its full development from the sixth century onwards. After 610 it was certainly a centre of independent power under its *afšin* (princes), and even before that it must have held a leading position among the many feudal states of Sogdiana. During the years 721 and 722 Pjandžikent suffered severe blows from the Arab invaders, but the final collapse took place half a century later, in 767-768, when the town was probably involved in the failure of the Khorasan revolt against Islam. Finds of Chinese coins in considerable

numbers show that close relations existed with the regions dominated by China; they confirm the commercial importance of the town and afford valuable chronological clues.

On the whole the Pjandžikent paintings achieve a high standard of excellence. In the classification made by M. M. Diakonov (apart from the negligible distinction he draws between sacred and profane work, a distinction neither clear nor relevant in matters of style), four different styles are distinguished, with some aspects common to all. Two of these would seem to be variants that led nowhere rather than really distinct phases. The bearded face, which Diakonov links up with Byzantine or Transcaucasian art and which in itself represents one entire phase, is an isolated image altogether different from Iranian and Central Asian renderings of the same type. Nevertheless, in the representation of a castle (Room 13, Sector VI) there are architectural details offering close

Rustam leading his Warriors against the Dev. Wall Painting from Pjandžikent, Room 41, Sector VI. Seventh Century. Hermitage, Leningrad.

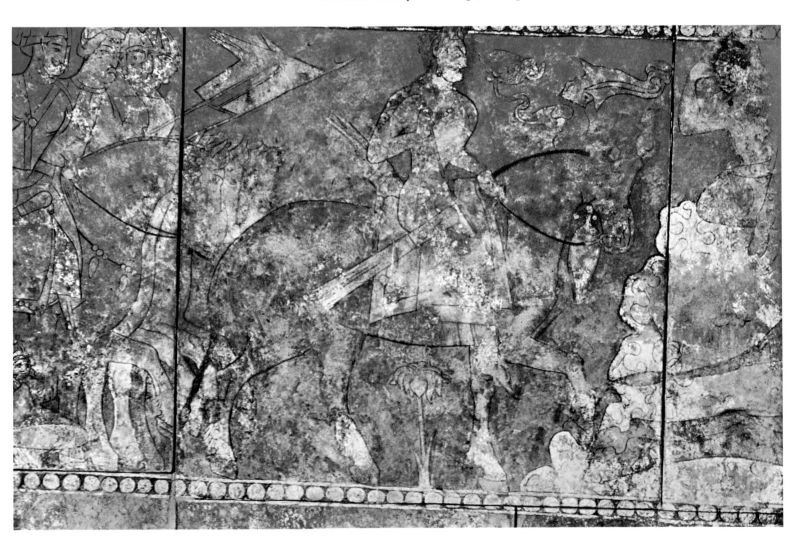

analogies to Christian churches in Armenia; one such detail is the entrance portal, very similar to those at Ani and Ereruk. Further reflections of the Christian art of the west are to be found in local sarcophagi. Judging by these instances, the presence of the bearded figure may rather be due to foreign imitation than to a stylistic development. For Nestorian Christianity was in fact so widely diffused in Sogdiana, and so deeply rooted there, that artistic phenomena of this kind can be accounted for historically. And since the fourth style is really a variant of the third, the development of painting at Pjandžikent can be reduced to two essential phases.

The first of these is exemplified in the paintings of Sector II, in a building that was apparently a temple. The chief characteristic here is an almost impressionistic handling of figures, with delicately shaded colours and unceasing efforts to render volumes—this

Rustam lassoing Avlod. On the right, Dragon spitting Flames from its Wounds. Wall Painting from Pjandžikent, Room 41, Sector VI. Seventh Century. Hermitage, Leningrad.

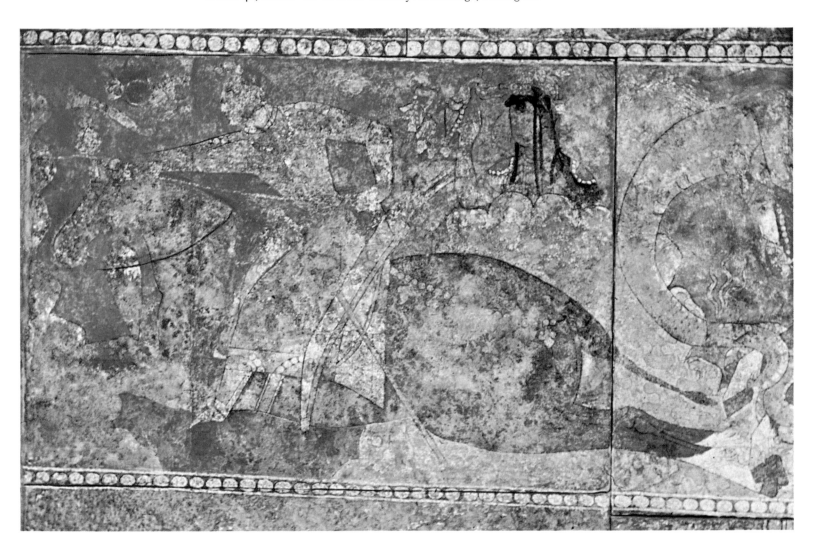

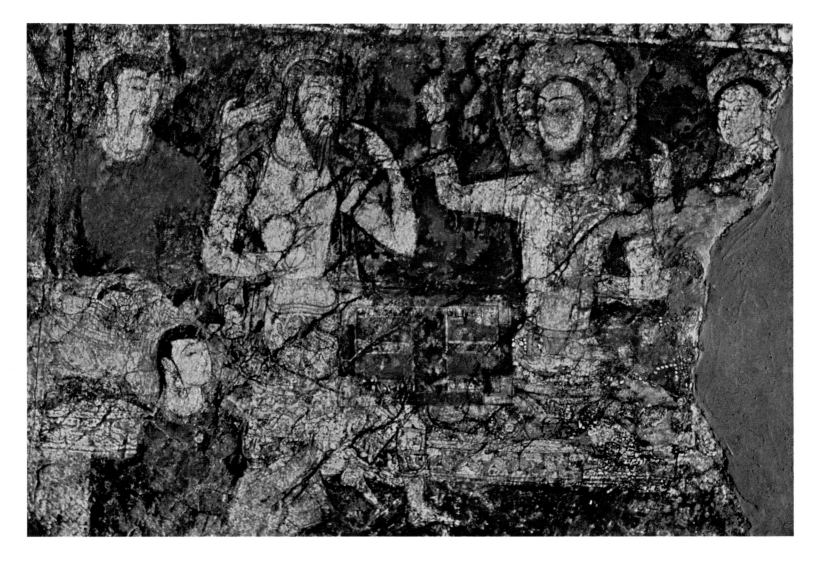

Two Men playing a Game. Wall Painting from Pjandžikent. Seventh Century.
Hermitage, Leningrad.

in striking contrast to an almost total disregard of perspective when it comes to archi-
tectural representation. In the second phase, images lose volume and movement but gain
in finish and the minutiae of detail, colour now being subordinated to line. While in the
first phase the illusion of relief is conveyed to a limited extent, in the second it completely
disappears and the composition remains essentially two-dimensional. Similarly, if in
the first phase it is possible to distinguish different ethnic types (Turks and Sogdians
according to the accepted view), in the second there is no attempt to render features or
facial expression—except in the case of monsters and demons figuring in legends—and
we have only the conventional uniformity of a few stock figures. This second phase is
apparently the one associated with the development of miniature painting, whether
Manichaean in Central Asia or Islamic in Iran.

It is interesting to note the parallelism between the evolution of painting at Pjandžikent and that of Sassanian sculpture and metal-work, which passed from a moderate emphasis on relief to a flat linear stylization of the utmost elegance. Other schools of Central Asia, like that of Kučā, developed on similar lines. It is not clear whether this evolution originated in Sassanian Iran or whether, as would seem more likely, it was due to a Central Asian element assimilated by Sassanian art. In any case, it may well have arisen from the evolution of the social structure itself. For this stylization and the renunciation of illusionist effects may be interpreted as symptoms of a growing detachment from reality, of a trend towards abstraction which, according to certain Soviet scholars, would have been the normal consequence of the social evolution of Pjandžikent and other centres organized on the feudal system, and of the crisis for which they were heading, had it not been for the Arab invasion, which completely overwhelmed the spirit and institutions of these civilizations.

The wall paintings of Pjandžikent adorned the larger buildings: temples and princely dwellings. Their subject-matter is often puzzling and has given rise to contradictory interpretations, depending on whether the commentary is Manichaean or Buddhist; they may even be reflections of a local faith attuned to passing currents of thought in outer Iran.

There are many scenes from epics and legends, presumably deriving from an analogous but independent tradition concerning the deeds of Iranian heroes. It is quite probable, for example, that the pictures in Room 41, Sector VI, painted in Diakonov's third style, represent an independent interpretation of the deeds of Rustam, the great Iranian hero, as related by Firdūsi in the *Shāh-nameh*, in the section of the poem called *haft khwān* ("The Seven Tales"). The correspondence, if not perfect, is nevertheless very close. The duel between Rustam and the knight Avlod, whom the hero takes prisoner Illustration page 45 with a lasso, is represented in one of the Pjandžikent panels exactly as it is described in the poem. This is followed by the slaying of a monster (a dragon with a female torso) and the war with the Dev, half-animal demons. Our first illustration shows Rustam, Illustration page 44 with the body of the slain dragon behind him, leading his warriors against the Dev, who in another panel are seen in flying chariots.

But while it is relatively easy to grasp the meaning of the subject represented here and to place it in its appropriate narrative context, this is by no means the case with other compositions. How enigmatic still, for example, is the large sacred scene of lamentation at the death of a hero, which some interpret as a Buddhist theme. The same is true of the panel showing two players before a sort of chess-board. This subject is certainly Illustration page 46 connected with the panels next to it, of which only a few vestiges survive. As A. M. Belcnickij has pointed out, it may illustrate either a Buddhist Jātaka story or some Turco-Iranian narrative theme. The nimbi encircling the heads of the different figures, the characteristic type of one of the two players, apparently derived from the type-figure of the Indian ascetic (complete with chignon), and the flames issuing from the shoulders of the royal personage—all combine to suggest a religious scene, inspired perhaps by a Buddhist subject or else by local traditions.

However that may be, there are some notable differences between these two compositions, rendered though they are in one and the same style. For the epic story the background is vague, enlivened by decorative motifs and cloud shapes. The religious composition is characterized by a uniformly bluish tone; there is an attempt to link together the different scenes, by framing them in semi-geometric patterns and placing the figures so that they form part of two panels at the same time. Line is not so much in evidence here, and details are worked out less carefully than in the pictures on heroic subjects, while some indication of the setting is required to mark the sequence of the religious narrative.

The Pjandžikent paintings evolved towards the decorative arabesque, as in the representation of pavilions characteristic of the third and fourth styles, and probably reflect a general taste common to all Sogdiana rather than the aesthetic demands of a ruling class. In these works we have reminiscences of narrative, pictorial and plastic tendencies that were already well developed at much earlier periods in the surrounding territories. It might well be possible therefore to single out various elements of Parthian or of Kushan origin.

Illustration page 49

One thing is certain: the first Pjandžikent style directly influenced the so-called "style without development" of Qïzïl. In the "Dance of Queen Candraprabha," from the latter site, we find that elongation of the figure characteristic of the wooden statuettes of dancing girls from Pjandžikent; and it recurs in many of the Pjandžikent paintings as well, although in these the elongation is less evident because as a rule the figures are seated. If that Qïzïl style, which also inspired the wall paintings of the Treasure Cave, failed to develop as might have been expected, it was not due to any inherent deficiency. The real cause was a powerful Sogdian influx from without, so compelling as to give a foreign stamp to all the works which it inspired.

Illustration page 50

We have no difficulty, moreover, in discerning echoes of Sogdian figurative conventions in Central Asian work of a later period. Thus the arrangement of the bows and ribbons on the dress of a Bodhisattva from Qočo, embroidered on a cotton fabric, is certainly derived from the Pjandžikent paintings, even though it is considerably later in date (ninth or tenth century); for it repeats the linear patterns found on many of the seated figures of the third and fourth styles. The persistence of a Sogdian pattern into so late a period was probably due to the activities of merchants and craftsmen, even if, historically speaking, it is not easy to explain.

There is little point in dwelling on further resemblances between the styles of Kučā and Pjandžikent, or on such minor details as various Central Asian and Sogdian works may have in common. It is enough to have pointed out the original features of Sogdian painting as revealed at Pjandžikent, and the influence which that art exerted on other regions near and far. In Sogdiana we find the source of an important stylistic trend, distinctly Central Asian in character, that was later to play its part in the rise of Indo-Iranian styles at Bāmiyān and Fondukistān. The striking elongation of the human figure at the latter site doubtless derives from Sogdiana, for the Fondukistān paintings are contemporary with those of the third style at Pjandžikent.

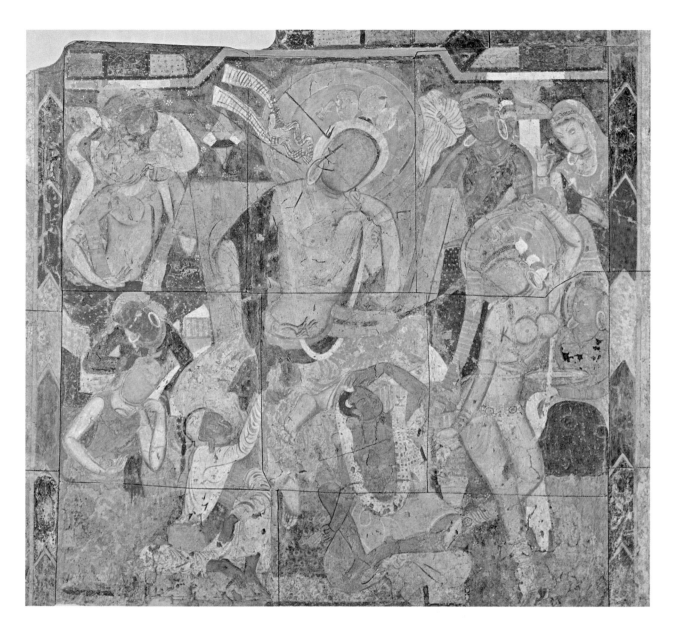

The Dance of Queen Candraprabha. Wall Painting from the Treasure Cave, Qïzïl. About 500. (Height 63″)
I B 8443, Indische Kunstabteilung, Staatliche Museen, Berlin.

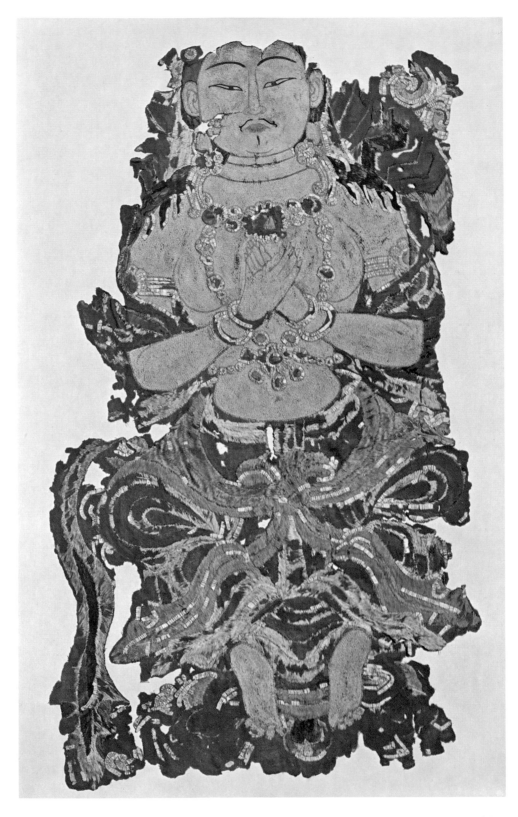

Bodhisattva. Silk Embroidery on a Cotton Fabric from Qočo. Ninth-Tenth Centuries. (Height 15″)
I B 4796, Indische Kunstabteilung, Staatliche Museen, Berlin.

As pointed out in the Introduction, Sogdian culture was widely diffused in Central Asia and its language became the lingua franca of Central Asian trade. The artistic influence of Sogdiana, however, was much more limited in scope and force, even allowing for the fact that Manichaean and Islamic miniature painters profited by the achievements of Sogdian artists and took over their two-dimensional space. But this in no way detracts from the originality of the Pjandžikent painters or their capacity for absorbing foreign influences that met with little response elsewhere.

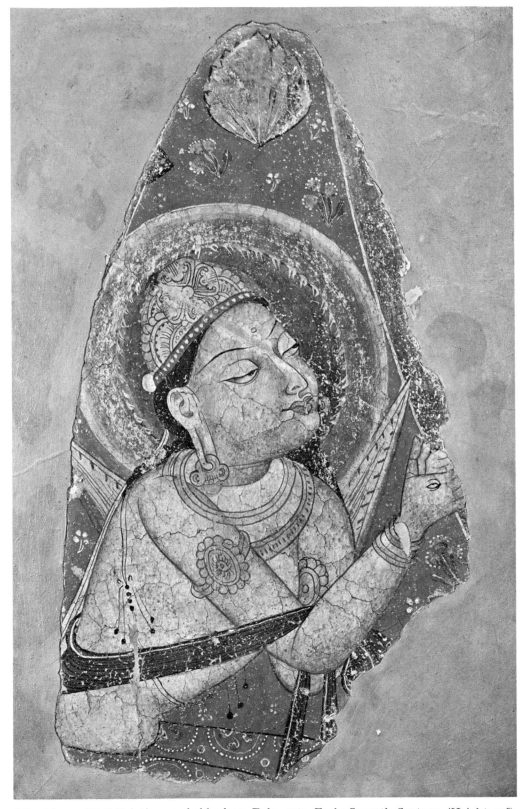

Worshipper. Wall Painting, probably from Balawaste. Early Seventh Century. (Height 21″)
Collection of the National Museum, New Delhi.

The School of Khotan

4

A ninth-century historian of Chinese art, Chang Yen-yüan, states that the influence of Sogdiana, or rather of outer Iran, must have been brought to China by that remarkable personality, the painter Ts'ao Chung-ta. He flourished during the Northern Ch'i period (550-577 A.D.) and founded a small school of painting. The ideogram *ts'ao* designates a part of Sogdiana, and so in Chinese usage might indicate the place he came from. However attractive the historian's statement may thus appear, there are some grounds for doubting it, even if Ts'ao Chung-ta was well known for his foreign style to Chinese writers and critics of different periods. Its essential characteristic was that in his painting of figures the clothes seemed to cling to the body as though they had been "bathing in them," to quote the expression of an eleventh-century critic Kuo Jo-hsü (*T'u-hua chien-wēn chih*, I, 9). The simile brings to mind an Indian panel of the Gupta period characterized by "wet clothes," but it might equally apply to some of the Pjandžikent paintings, especially those of the first style; for example, the goddess on the left in the scene of lamentation at the death of a hero.

Although Ts'ao Chung-ta might have come from Sogdiana so far as dating is concerned, that does not quite dispel our doubts. Unfortunately not a single specimen of his work, or any copy, has come down to us. There can be no doubt, however, that he was of Western origin. He may have painted in an Indo-Iranian style, for his work was of Buddhist inspiration. Instead therefore of postulating the spread of artistic influence into China from Sogdiana, we should probably see it as coming from Bāmiyān and Kakrak. The gigantic sculptures of Yun-kang and Lung-men would go some way towards proving it. But the evidence available is too meagre to settle the question. For the only school of painting in Central Asia which, alongside of a workmanlike production of murals and paintings on wood, can boast of great creations appreciated by Chinese artists and critics is that of Khotan. Documented, unfortunately, by only a few surviving works—and these heterogeneous in type, source, period and subject—the school of Khotan gives evidence of having absorbed Indian, Sassanian, Chinese, Sogdian and even perhaps Chorasmian influences, all of them assimilated and recast with indisputable originality. Its influence marks the nascent art of Tibet and is reflected in the reputation won by great Khotanese painters in China at the beginning of the T'ang dynasty.

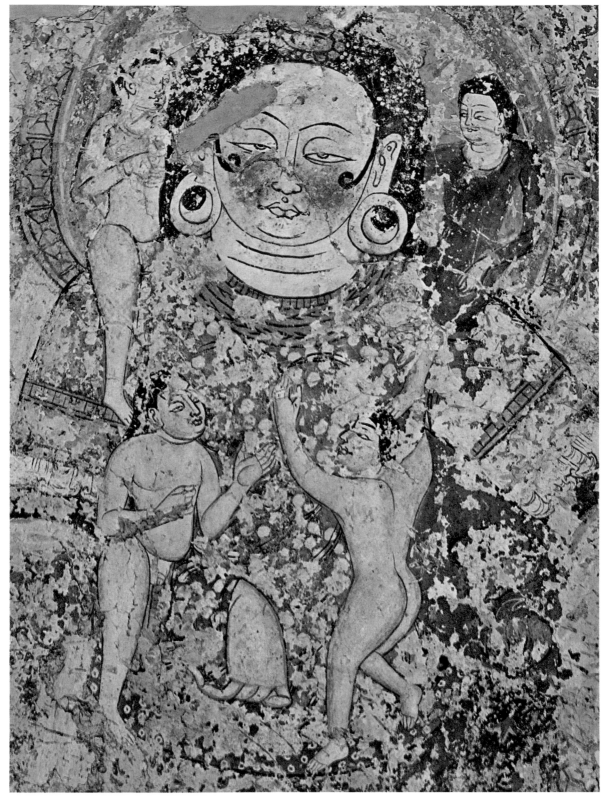

Hāritī with Five Children. Wall Painting from Shrine XII, Farhād Bēg-yailaki. Mid-Sixth Century. (Width c. 18½″) 20 F. XII 004, Collection of the National Museum, New Delhi.

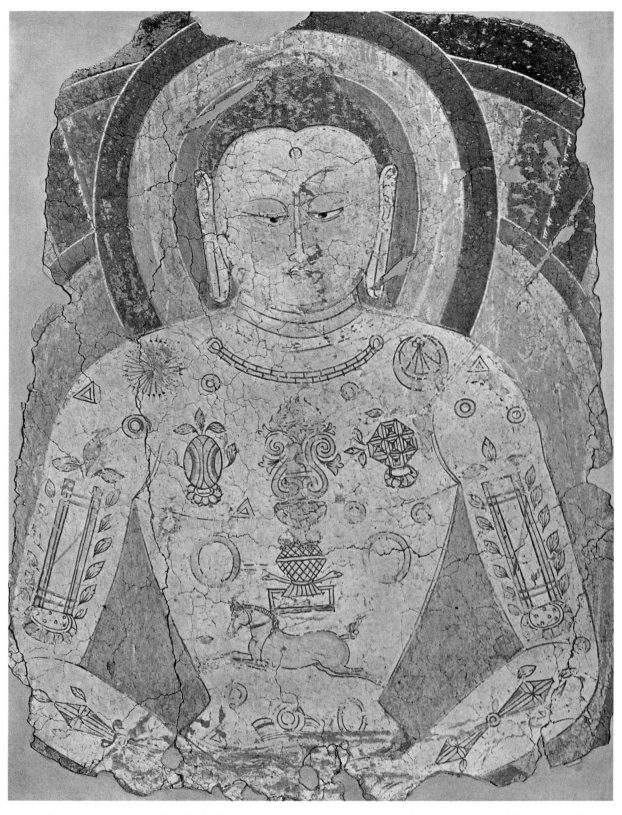

Buddha in Meditation. Wall Painting, probably from Balawaste. Mid-Sixth Century. (Height c. 31½″)
HAR. D., Collection of the National Museum, New Delhi, Gift of L. Harding.

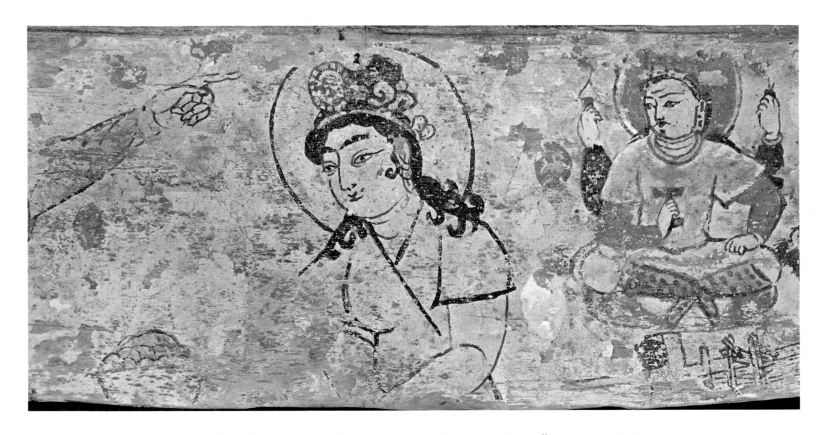

The "Silk Princess," detail. Wooden Votive Tablet from Dāndān Öilüq (Khotan), Sanctuary D x. Probably Seventh Century. (7½×4⅝") British Museum, London.

Out of the blend of foreign influences enumerated above, a new style now emerged. It can be seen in the wall paintings of the shrines and monuments of the Domoko group east of Khotan, which date to about the middle of the sixth century. Extremely interesting in its treatment of the human form, its chief characteristic is a preference for figures shown in front view, with round, almost discoid faces. In spite of notable analogies with certain works of Bāmiyān and Kakrak, we are here confronted with an original style whose features are a strictly frontal presentation, highly developed stylization, a flat, almost two-dimensional design, and a tendency to geometric simplification which also occurs in some votive paintings on wooden panels from Dāndān Öilüq. These panels are characterized by a peculiar technique of drawing on the colours, and by vague, sporadic reminiscences of Indian art of the Gupta period. From this style derive the geometric simplifications of anatomical details occasionally noticeable at Kučā (for example, the use of circles to indicate and outline the knees). This is quite in keeping with the spirit and manner of the frontal images found in the Domoko area, which observe laws of proportion and schematic devices based on the segment of a circle and the ellipse. Further, all these forms correspond—almost as if they were variations on a type-figure— to the schematic simplifications and geometric patterning laid down in medieval technical

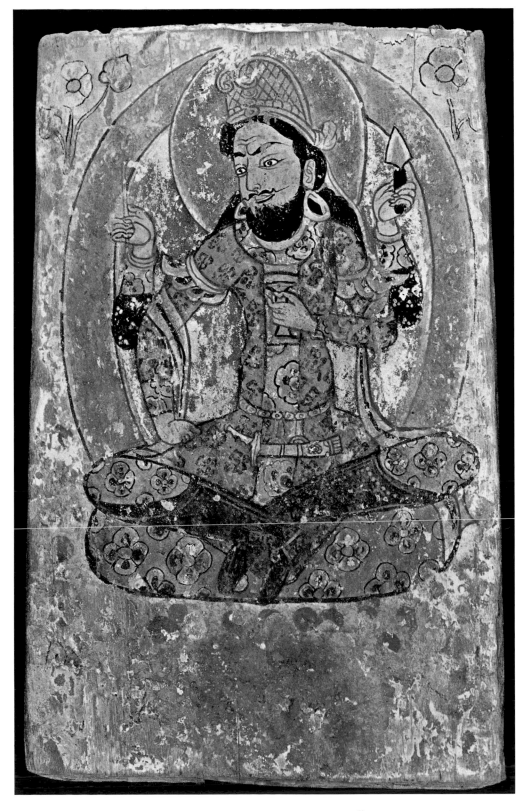

The "Iranian Bodhisattva." Wooden Votive Tablet from Dāndān Öilüq (Khotan), Sanctuary D vii. Probably Seventh Century. (13×8¼") British Museum, London.

handbooks associated with the methods of Villard de Honnecourt. Perhaps, therefore, while falling into line with a definite trend, revealed in their mystical overtones and expressive power, these forms also answered a general need for more rapid execution.

Illustration page 54
Illustration page 55
This style of figure painting can be clearly seen in two works, the figure of Hāritī, from a shrine at Farhād Bēg-yailaki, and the surviving bust of a Tantric Buddha in meditation, covered with symbols, probably from Balawaste in the Domoko region. The two principal figures are shown in front view, even if the effect is attenuated in the picture of Hāritī by the five children, who represent the traditional attendants of a demon here transformed into the protectress of childhood. The elongated matching eyes drawn Indian fashion, the flat symmetrical faces, the effects of the concentric nimbi and, above all, the highly stylized ensemble give these figures their singular appearance, which is not devoid of grandeur and distinguishes them from the frontal images of Bāmiyān (e.g. the handsome Bodhisattva of Cave K 3 or that of Group E). Probably it was the ancient Gandhāran technique of the stylized stelae, taken over at Khotan, Bāmiyān and Kakrak, which suggested these elaborations. And they were very little modified by the Sassanian Iranian element that entered into them. The robe worn by Hāritī has Iranian characteristics, as do some minor details in the shrine. The Iranian preference for the profile by no means excluded the occasional use of frontal presentation.

The probable Gandhāran origin of this treatment of figures is confirmed by historical and archaeological data. Khotanese culture, characterized by the use of a language of its own, of the East Iranian (Saka) type, did in fact extend to different areas at different times. Its principal centre was at first Yotkān and then Khotan, situated close by. Freed from the domination of Yarkand in 60 A.D., the kingdom of Khotan became one of the leading powers of Central Asia, and in the Han period the Chinese general Pan ch'ao succeeded in converting it into a confederate state. Chinese political influence remained paramount for a long time, but the Khotan area, which in large measure preserved its independence, must have had close ties with the Indo-Afghan empire of the Kushans. It would appear that the second Kushan dynasty was connected with Khotan in the person of Kanishka, its greatest king (128?-141? A.D.). Khotan certainly felt the weight of Kushan power in the years immediately following 120 A.D. For these reasons—and others connected with the caravan traffic in the first centuries of our era—a very powerful Gandhāran influence was here at work, of which there is ample evidence in the sculpture and architecture of the region.

The rise of Mahāyāna Buddhism did much to foster this influence and gave Khotan a different religious complexion from the other regions of Central Asia; Kučā, for example, was a centre of Hīnāyāna Buddhism. There also emerged here and there local characteristics which accentuated the originality of Buddhist thought in Khotan. The bust of
Illustration page 55
the Buddha from Balawaste, with the symbolic motifs of the Tantric type adorning it, seems of a piece with the local predilection for light values and stylized, leaf-shaped flames. This local style appears in various forms and sometimes more clearly in other images to be considered further on. Among the Tantric symbols in the Balawaste Buddha are the sun and the moon, the two flaming jewels on lotus flowers (the one on the left

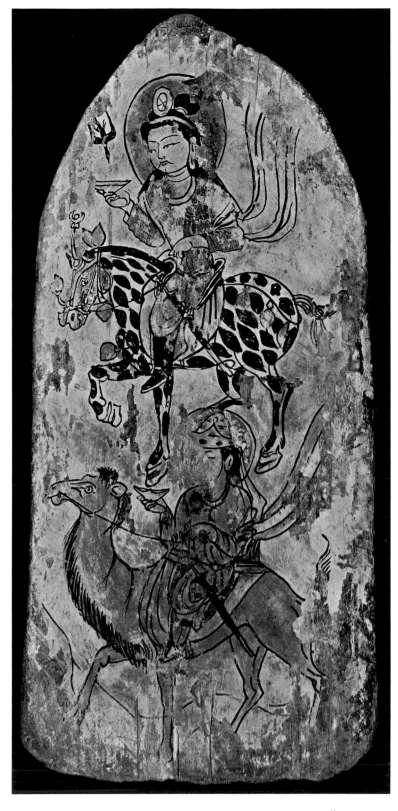

Scene from a Khotanese Religious Legend. Wooden Votive Tablet from Dāndān Öilüq (Khotan), Sanctuary D VII. Probably Seventh Century. (13⅛×7″) British Museum, London.

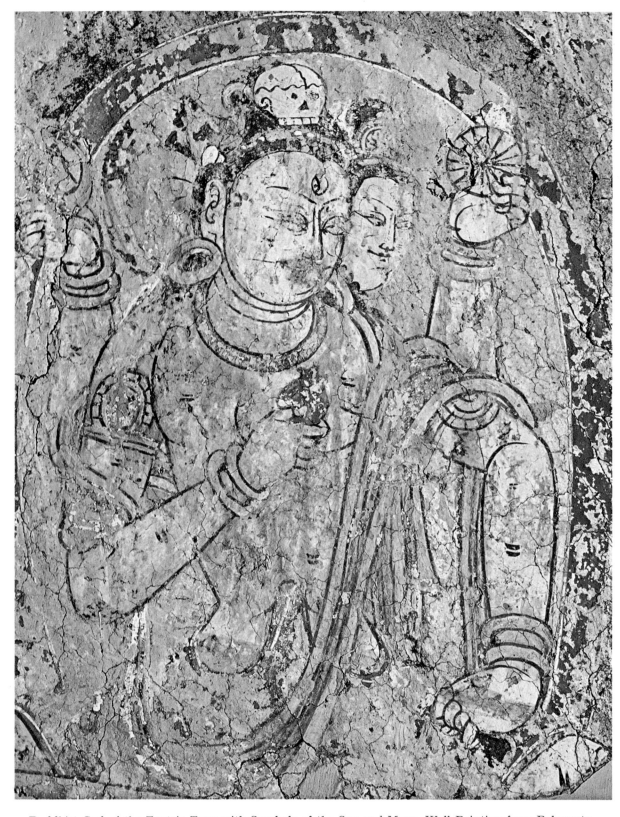

Buddhist God of the Tantric Type with Symbols of the Sun and Moon. Wall Painting from Balawaste.
Seventh-Eighth Centuries. (Height c. 12″) BAL. 0200, Collection of the National Museum, New Delhi.

veined and ellipsoidal, that on the right faceted and polygonal), the two books drawn Illustration page 55
on the upper arms, also surrounded by flames and standing on lotus flowers, together
with the *vajra* (thunderbolt) on the forearms. To these are added a chain ornament,
a central motif alluding to life and immortality, a horse at the flying gallop and a crown
of the Sassanian type obviously alluding to the royal power.

Leaving aside the particular symbolism of this figure and related problems, we need
not wonder at the persistence of figurative motifs which, even though remodelled with
genuine originality, stem from ancient Gandhāran sources common also to Bāmiyān and
Kakrak. Nevertheless, in the Domoko region again, we find works in a totally different
style, dating, curiously enough, to about the same period as those discussed above.
Such is the beautiful picture from Balawaste of a worshipper kneeling in prayer, which Illustration page 52
in structure, colouring, costume and style seems distinctly Indian. Though less fully
developed, it is very much like some of the Ajantā figures datable to the early seventh
century. Only the flames issuing from the shoulders—assuming that the two triangular
points framing the nimbused head are meant to be flames—bring us back to a Kushano-
Khotanese setting. The eye drawn on the back of the hand clasped in prayer again con-
fronts us with an enigmatic symbolism. It has given rise to varying interpretations, but
it is not a symbol alien to Central Asia; it occurs, for example, in the Qïzïl paintings.

The variety of styles in the Khotan area does not end with its wall paintings. The
pictures in the Tārišlark temple are remarkably like those of Qïzïl, in spite of variants,
especially in the dress (the white mantles of the Buddhas and Bodhisattvas, for example).
The way the garment is draped round the body recalls the Balalik Tepe paintings,
except for the wealth of colour and ornament and the cut—the garment at Tārišlark
being monochrome. This would seem to contradict the Buddhist pilgrim Sung Yün,
who declared in 519 A.D. that costumes in Khotan and Kučā were identical. Sassanian
influence on the composition is in any case clearly seen in the long ribbons *(kustī)*
floating behind the head and the beaded ornaments.

The direct connection between local art and the Sogdian styles is corroborated in the
"Iranian Boddhisattva" of Dāndān Öilüq by the characteristic elongation of the body Illustration page 57
and other features. Black-bearded, four-armed, wearing a pale green close-fitting tunic,
he is seated on a cushion and represented with nimbus, halo, crown, dagger and other
attributes—not all of them clear. That this fine votive image, painted on a wooden
tablet, is of a religious nature cannot be doubted, even if it is not easy to interpret;
on the back of the panel is depicted a three-headed goddess of the Tantric type, Buddhist
certainly but of Sivaist origin. The interpretation of Natalia Diakonova, who sees in
it a goddess connected with silk—on the strength of an iconographic analogy with other
images, all of them from Dāndān Öilüq—is not entirely convincing.

In any case, this figure closely resembles a divine personage shown on a wooden
tablet whose subject is the legend of the Silk Princess, concerning the introduction of Illustration page 56
silkworm culture in Khotan. This personage too is four-armed and has two of the attri-
butes of the Iranian Bodhisattva, the cup and the knife with a short triangular blade; Illustration page 57
both are wearing a crown. Similar images are found, with minor variations, on a number

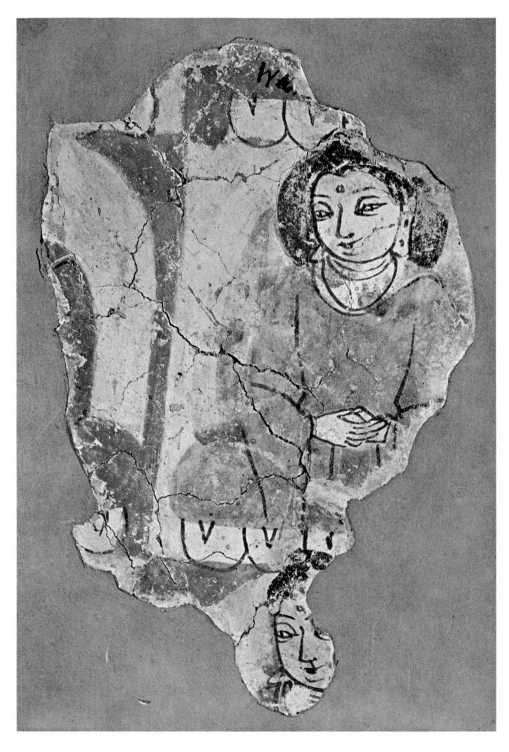

Buddha in Meditation. Wall Painting from Dāndān Öilüq (Khotan). (Height 7″)
I B 9273c, Indische Kunstabteilung, Staatliche Museen, Berlin.

of panels from Dāndān Öilüq. There existed, then, a genuinely Khotanese iconographic type which recurs, with more or less the same religious value, in both of the works we have examined, the second of them a narrative scene, if somewhat summary in treatment. In the figure of the Silk Princess, and in other figures on similar panels, is a suggestion Illustration page 56 of Chinese influence which proves that various tendencies, Iranian, Indian and Chinese, coexisted in these particular works of Dāndān Öilüq. They are datable to some time between the sixth and eighth century, most probably in the latter half of that period. They cannot in any case be later than 791, the year when the site was finally abandoned.

The same Chinese element, rather accentuated and not in the Mongolian features alone, is seen in another, altogether different panel. It must illustrate some local religious Illustration page 59 legend, to judge by the cup held in the right hand both of the horseman and of the noble personage on the dromedary, by the nimbi round their heads and by the wild bird swooping down. Linear design is here emphasized in the Chinese manner, but there are Sassanian reminiscences and intermediate interpretations which recur at Turfān.

We have now examined several outstanding examples of Khotanese painting whose level of achievement roughly corresponds to that of the Indian *śilpin*. They rise above the standards of mere craftsmanship, to be sure, but fall short of those of the highest form of art. The Chinese element present in some of these works (but absent from those of Domoko) shows the increasing impact of Chinese art on the whole Khotan area— an impact which reached its height under the T'ang dynasty. It proves too how rich was the variety of stylistic influences at work. All the more reason then for regretting the scarcity of the archaeological finds so far made and the disjointed picture they give. Nevertheless some of the images, by their very nature, would *ipso facto* diminish or even rule out entirely any Chinese influence, by giving full scope to local and Indian elements. The divergence in style between the figure of the Iranian Bodhisattva and Illustration page 57 that of the Tantric divinity on the back of the same panel is obvious. This remains true even though in each there are minor details of similar taste and in spite of a possible symbolic and religious link between the two figures. Similarly the Chinese element vanishes in the four-armed divinity accompanying the Silk Princess, although there is no trace Illustration page 56 of any discontinuity of style between the different personages of the legend.

There is nothing surprising therefore in the close relationship, both in subject and style, between the Tantric divinity from Dāndān Öilüq and another from Balawaste. In the latter, besides the local style in structure and details, Indian elements can also Illustration page 60 be felt. We cannot establish with any certainty the identity of these two figures which, despite some differences, resemble one another in appearance. Each is three-headed with almost identical variations in the three faces; the one in the centre has a third eye. Each bears on its four hands identical attributes—the sun, the moon, the *vajra* (thunderbolt) and a piece of fruit (in the Balawaste figure, certainly a pomegranate). Apparently ithyphallic, they differ in their head-dress (that of Balawaste having a skull on top) and in the tiger skin which gives the Dāndān Öilüq image a Sivaistic aspect. Both undoubtedly convey luminous and astral values connected with the sun and moon which, as already pointed out, were particularly important in Khotanese Buddhism.

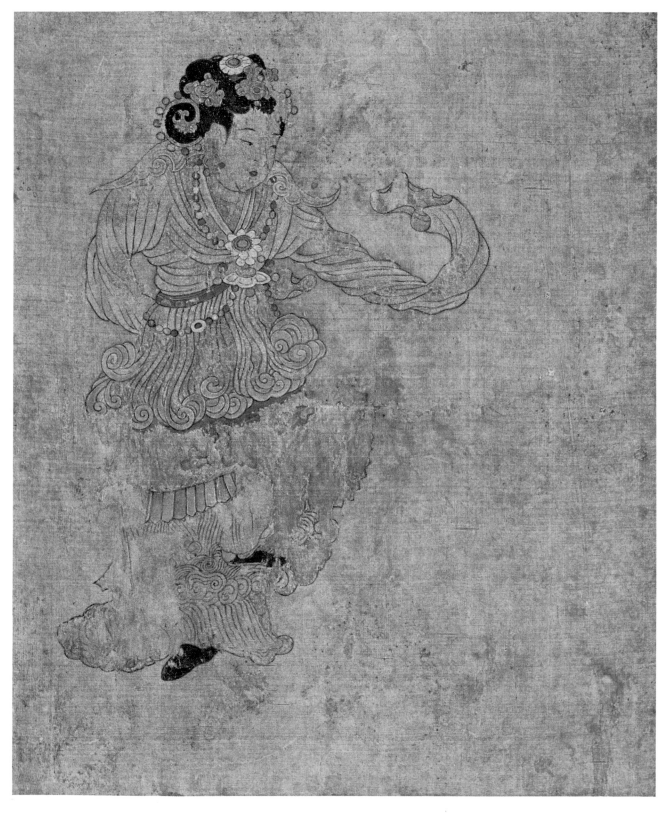

The Berenson Scroll, detail: Dancer. Copy made before 1032 of a Seventh-Century Painting by Wei ch'ih I-seng. By Courtesy of the President and Fellows of Harvard College. Villa I Tatti, Settignano, near Florence.

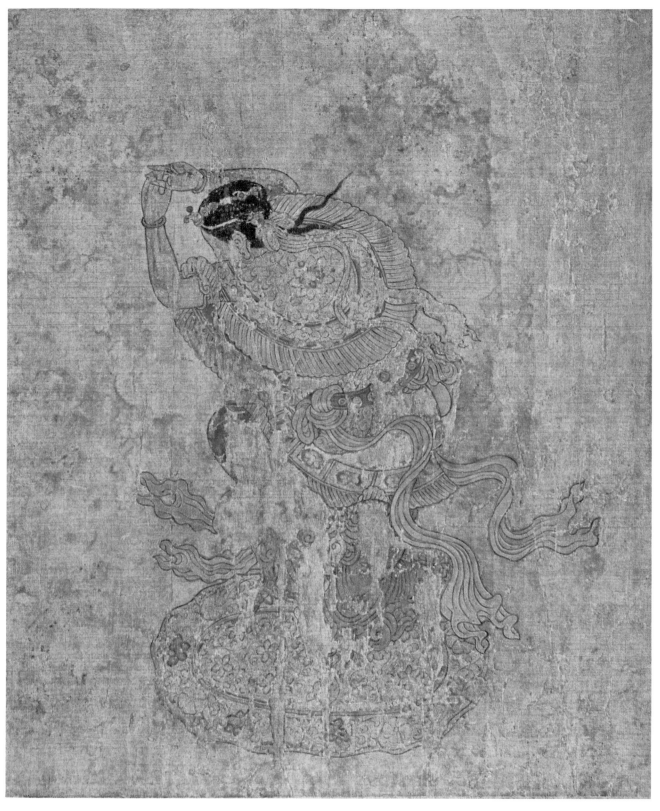

The Berenson Scroll, detail: Dancing Girl. Copy made before 1032 of a Seventh-Century Painting by Wei ch'ih I-seng. By Courtesy of the President and Fellows of Harvard College. Villa I Tatti, Settignano, near Florence.

It is possible that these divinities may be related in some way to the four-armed female figures on Sassanian and Sogdian cups which, in addition to the sun and moon, carry other symbols, not always the same as those of the male divinities of Khotan but more or less equivalent in meaning. Important and interesting though it is, the problem cannot be dealt with here and has been broached only to bring out the peculiarities of Khotanese iconography and their religious implications, and to emphasize the connection between the style of these images and their religious content.

In the social and artistic framework of a world so complex as this, subject and style interact and are together conditioned by external factors. These in turn are bound up with a fixed symbolism and iconography dependent on religious thought, which may at one time accept and at another reject styles and forms which, however vigorous, may be ill adapted to the expression of values peculiar to another environment and made familiar by a long-standing tradition. Nevertheless, whatever their debt to this or that element of foreign style, the works created at Khotan are always highly original in character and demonstrate the vitality and expressive power of that school.

The best known of the Khotan paintings was the lovely Nāginī rising from the waters of an artificial fountain in Temple D. II at Dāndān Öilüq. Unfortunately all that now remains of it is a photograph. This, however, is enough to show the fusion here of Indian and Chinese elements with perhaps a Chorasmian strain that lingered until the eighth century. For the gesture of maidenly modesty (similar to that of the Medici Venus) often recurs in the clay statuettes of Chorasmia, thus testifying to the ever-renewed contacts and interchanges characteristic of the art of Central Asia.

Much more important than these anonymous works, representative of the varied but general taste of the school of Khotan, is the fact that some of the greatest Khotanese painters worked in China in the late Sui and early T'ang period and made a deep impression on China's acute and exacting critics. Wei ch'ih Po-chih-na, called Wei ch'ih the Elder, and his son Wei ch'ih I-seng, or Wei ch'ih the Younger, in spite of their foreign style, were distinguished among the artists of their day, especially the latter. Of purely Khotanese stock ("Wei ch'ih" probably corresponds to the Sanskrit "Vijayā"), they may have been related to the reigning dynasty, for according to Hsüan-tsang the family name of the king of Khotan was Wei ch'ih. There were three painters in the family, one of whom, Wei ch'ih Chia-seng, remained at home. Po-chih-na arrived in the Chinese capital Ch'ang-an in the last years of the Sui dynasty (589-617) and was there ennobled. Famous for his (narrative?) paintings on Buddhist themes and his renderings of flowers and exotic objects, he painted in a "free and vigorously expressive" style. His son Wei ch'ih I-seng was sent to China by the king of Khotan some time probably between 620 and 630. There, having inherited his father's title, he worked in various temples, more especially in the one called Fêng-ên ssŭ, where he took up residence; it became a meeting place for princes and monks from Khotan visiting China. Remaining active in all probability till about 710 and often compared with his contemporary Yen Li-pen —despite considerable differences in subject-matter and style—I-seng had a predilection for Buddhist themes (both murals and scrolls), flower pieces and exotic subjects.

In various texts it is said that he could paint flowers as if in relief (literally "concave and convex" in the translation of Osvald Siren) and that his line was as taut and strong as "bent and coiled iron wire."

It is precisely these characteristics, analysed at greater length in other texts, that entitle us to consider the following as copies of lost originals by Wei ch'ih I-seng: a Śākyamuni of quite uncommon power (Museum of Fine Arts, Boston, copy by Ch'en Yung-chih), the Berenson Scroll, and a fragmentary scroll in the Stoclet Collection, Brussels. To these may be added the picture of Lokapāla Vaiśravana (a divinity worshipped throughout the Khotan area), which has come down to us in two copies of different periods, one of them apparently the work of Wu Tao-tzŭ. In each of these works, particularly in the Boston Śākyamuni and the Berenson Scroll, there is a reflection of I-seng's brushwork and his feeling for style and composition, which far surpasses anything seen in the wall paintings or the wooden panels. Each is the expression of a powerful personality perfectly able to bring into being a small school in the proper sense of the word. The very fact that I-seng's works were copied several times demonstrates their importance and the success they enjoyed. In the "Dancers" of the Berenson Scroll, the whirling Illustrations pages 64-65 movement of the dance, its strict confinement to the oval carpet, and the very attitude of the figure, all recur in the wall paintings of Tun-huang, though with less grace and vigour (e.g. the paintings dated 642 in Cave 220, according to the numbering of the Illustration page 125 Tun-huang Institute).

What interests us here, however, is not so much the similarity of subject (interpreted somewhat differently), which may derive in its entirety from the more or less similar compositions of Gandhāra and Iran, as the fact that the two Khotan painters introduced into China a sense of colour and a way of handling it (in clotted dabs and curling strokes) which, although quite foreign to the Chinese mentality, were welcomed by local critics, who saw in it the expression of an exotic art capable of enchanting the shrewdest connoisseurs. Khotanese painting had thus attained in its finest exponents exceptional powers of expression and vigour of style. The achievement of these artists was due to their parting company with the ways habitual in the world that moulded them. This fact confirms the very high quality of Khotanese painting at its best.

Along with the high reputation it won goes the influence it had on Tibet, with which Khotan already had close relations in the eighth century. The rGyal rab records the presence of Khotanese painters and monk-translators in Tibet at the time of King Ral pa can (K'ri gtsung lde btsan Ral pa can, 815-838 A.D.). We find later in the temple of I wang a pre-thirteenth-century chapel painted in the Khotanese manner (Li lugs). There are t'anka (banners) in the same style; late reminiscences also of works at Tārišlark and Dāndān Öilüq in the Kumbum (sanctuary) of the great temple of Gyantse (fifteenth century) and, finally, faint echoes of Wei ch'ih I-seng in the images of Vaiśravana of various periods. All this goes to show the prevailing influence which Khotan art exercised on Tibet at different times and in paintings varying in subject and type. The vitality of its styles is confirmed and illustrated in the imprint it left on the genesis and substance of Tibetan art.

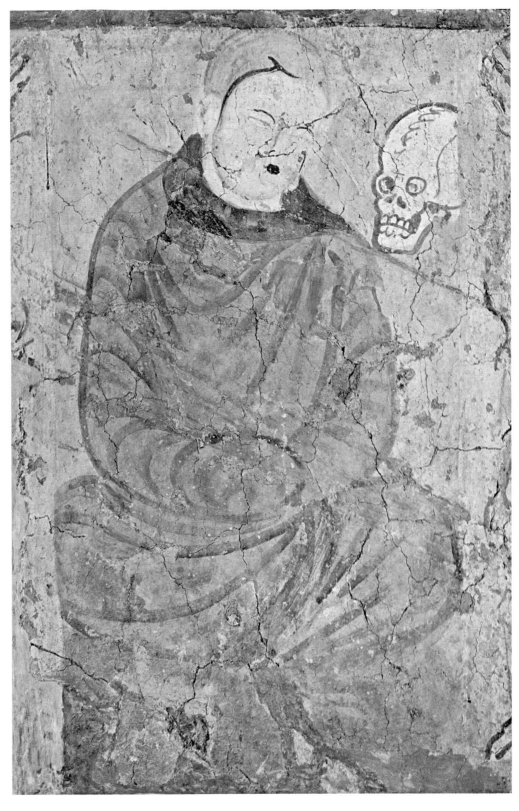

Monk in Meditation before a Skull. Wall Painting from the Cave of the Navigator, Qïzïl. About 500 (?).
(Width 14¼″) I B 8401, Indische Kunstabteilung, Staatliche Museen, Berlin.

5

NOTWITHSTANDING recent Chinese discoveries in the Buddhist caves of K'o-tzu-erh ming-wu, a small but important site west of Kučā on the road to Aqsu, our knowledge of Kučean painting still depends largely on the discoveries made and documents collected in the early decades of this century by the great European and Japanese expeditions, especially the German.

Kučā, in itself an important caravan city, as well as the centre of a distinct linguistic area rich in literary works mainly of Indian inspiration, also played a part of prime importance in the history of Central Asia. It developed a composite but original civilization, expressed in many monuments of art which, to judge by the surviving paintings, came mostly from the monasteries and rock-cut shrines of Qïzïl and Qumtura, sites in the vicinity of the caravan centre proper. Artistic development at Kučā itself is so closely connected with that of these neighbouring centres, east and west, that it can only be properly studied by taking due account of their works.

These include the Tumšuq group in the west, of which only a few painted fragments remain, some of them remarkable for vivid colouring and clarity of design, so much so as to appear stylistically distinct from the Kučā paintings. Eastwards, again, lies the Qarāšāhr (ancient Agni) area, linguistically separate and often politically hostile to Kučā, though equally close to its rival in matters iconographic and stylistic. Yet the whole history of Kučā is one strong urge towards autonomy and even expansion, which led it to combat opposing forces with extraordinary tenacity and courage.

Its political and cultural outlook explains the hospitality it extended to Iranian exiles fleeing the Islamic destruction of the Sassanian empire in the middle of the seventh century. René Grousset accordingly called Kučā "a real Coblenz" for the Sassanian *émigrés*. It is understandable that the presence on its soil of Sassanian nobles and feudal vassals in exile might affect artistic development there; similarly its dependence on China, which the town loyally accepted (Kučā became in 658 the seat of the Chinese government of the Tarīm basin), might account for the presence of Chinese characteristics in two of the Qumtura caves.

But there are other explanations of the marked Iranian and Chinese influences, for those works, in spite of the strong foreign stamp on them, remain indubitably Kučean.

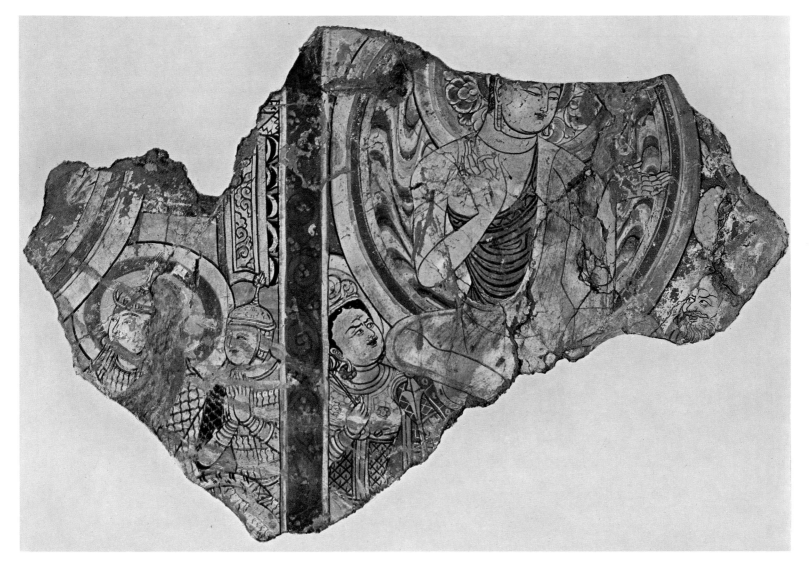

The Buddha, Vajrapāṇi and a Bearded Figure. Wall Painting from the Eastern Zone of Tumšuq. Sixth Century (?). (Height 19¼″) I B 8716, Indische Kunstabteilung, Staatliche Museen, Berlin.

In religion Kučā, like Bāmiyān, was a centre of Hināyāna Buddhism where sects intermediate between the Great and the Little Vehicle, like the Lokottaravadin, had for a long time been dominant, a fact which might well have facilitated the influx of Indo-Iranian currents. Yet the existence of works with a distinct style of their own, of uncertain date, both from Qïzïl and, in greater number, from K'o-tzu-erh ming-wu, a peripheral centre independent in spirit, place the whole problem of the origins and evolution of art in the Kučā region in a context very different from the one generally accepted. The style in question uses thick emphatic outlines, shows a marked concern for chiaroscuro effects, and the figures are treated schematically so that they look as if composed of geometric patterns. In spite of an unmistakable Kučean imprint, can we not discern

here at least a reminiscence of the figurative technique used in the cave paintings of the Wei and Sui epochs at Tun-huang? We cannot be sure whether the resemblance to the Tun-huang paintings is due to Chinese influence—a thing historically possible. Or can the two centres have followed courses analogous but independent? Or again, might it be the normal development from a common background, obviously connected with the figurative trends seen at Mirān? There is no easy answer. Yet the problem is vital to a study of the art of Kučā and of Central Asia in general, and all the harder because the dating of these paintings themselves is nearly always hypothetical.

It is generally considered that painting at Kučā began in the fourth century A.D. and continued, somewhat attenuated, throughout the eighth century, and even beyond. In that period of time two main phases can be distinguished. The first, of Indo-Iranian type, flourished around 500 A.D. while the second, more strongly Iranian, reached its peak about 600-650. A transitional phase in the second half of the sixth century has also been identified, and, as already mentioned, we must consider too the Chinese influences discernible in two of the Qumtura caves, affecting the latest developments of style at Kučā in the seventh and eighth centuries with extensions into the ninth.

The volume of paintings at Kučā is so great, however, that such general divisions require qualifications for several reasons. Alongside of general tendencies in style, specific differences may have coexisted, and the personality of the artists must also be taken into account. The signatures on a number of the painted wooden tablets prove that the artists had no desire to be absorbed into a mystic anonymity as in India or to retire behind their subjects as in Iran. Moreover, the difference in style between works attributed to the same phase is often so great as completely to eliminate any idea of an identical development and also to render the distinction between the two phases a mere matter of convenience, subject to modification and revision.

The paintings of the first phase do, however, show signs of a general Indian tendency as, for example, in their evident concern with relief and chiaroscuro, in the draughtsmanship and figures embodying minor Sassanian features. The vigorous cowherd Illustration page 72 leaning on a knotted stick (that looks like a club) is a good illustration of this style and its preoccupation with volume, seen in the curved concentric lines of his clothing, recalling the characteristic style of the Mingora sculptures in the valley of the Swat. The same concern with relief appears as obviously in the picture of a young ascetic in his shelter Illustration page 74 of foliage which decorated either a vault or a pendentive in the Cave of the Navigator at Qïzïl. The elongated, dreaming eyes of this figure, of about the same date as the cowherd, show a still stronger Indian influence. The treatment of volume here is not confined to the linear rendering of the hair and the concentric, almost elliptical curves, but is effected also by the contrasting colours, the handling of the beard and the ornamentation of the scarf over the shoulders.

The difference between the first and the second phase of painting at Kučā becomes most clear if we compare the image of the young ascetic with another—that of the mystic ascetic Mahākaśyapa. The latter comes from the so-called Large Cave at Qïzïl and is Illustration page 75 at least a century later than the two previous works. In its high degree of stylization,

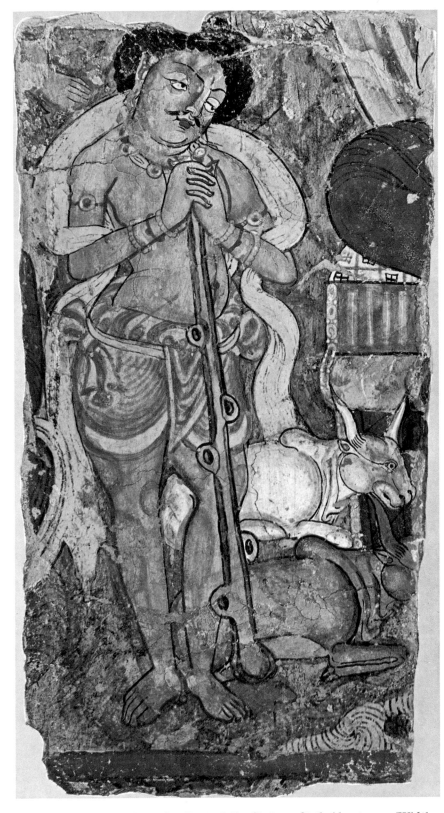

Cowherd. Wall Painting from the Cave of the Statues, Qïzïl. About 500. (Width 10¾″)
I B 8838, Indische Kunstabteilung, Staatliche Museen, Berlin.

its relatively flat construction rendered more severe by the schematized eyebrows, the Illustration page 75 folds of the mouth and chin and the shape of the eye, this composition with a neutral background of stylized flower patterns recalls the ascetics of Byzantine art. Iranian influence has penetrated and destroyed every trace of Indian style so as to achieve an awe-inspiring expression instinct with a peculiar spirituality. The facial features of Mahākaśyapa, less powerful in expression, recur in other pictures of monks and ascetics.

Swimmers. Wall Painting from the Cave of the Navigator, Qïzïl. About 500. (Width 13½″)
I B 8398, Indische Kunstabteilung, Staatliche Museen, Berlin.

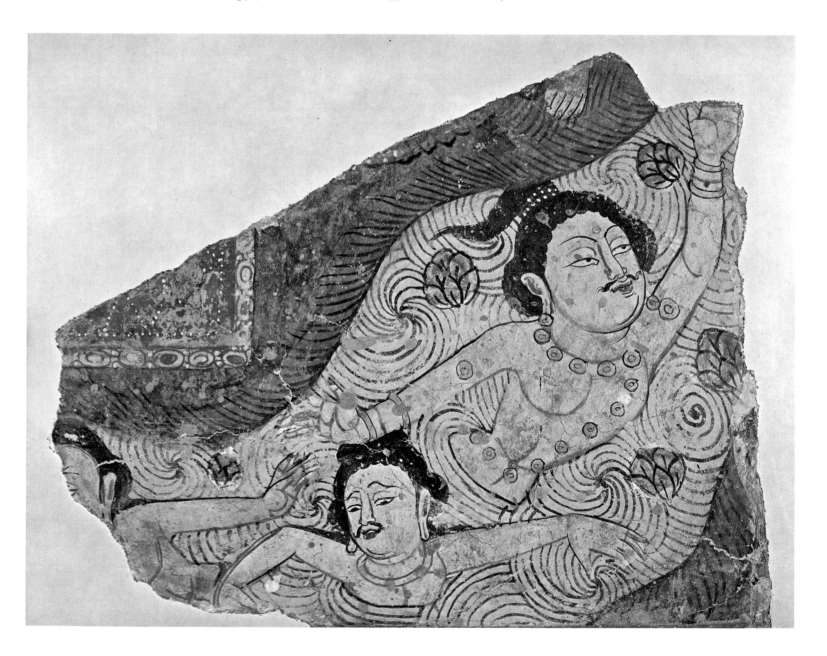

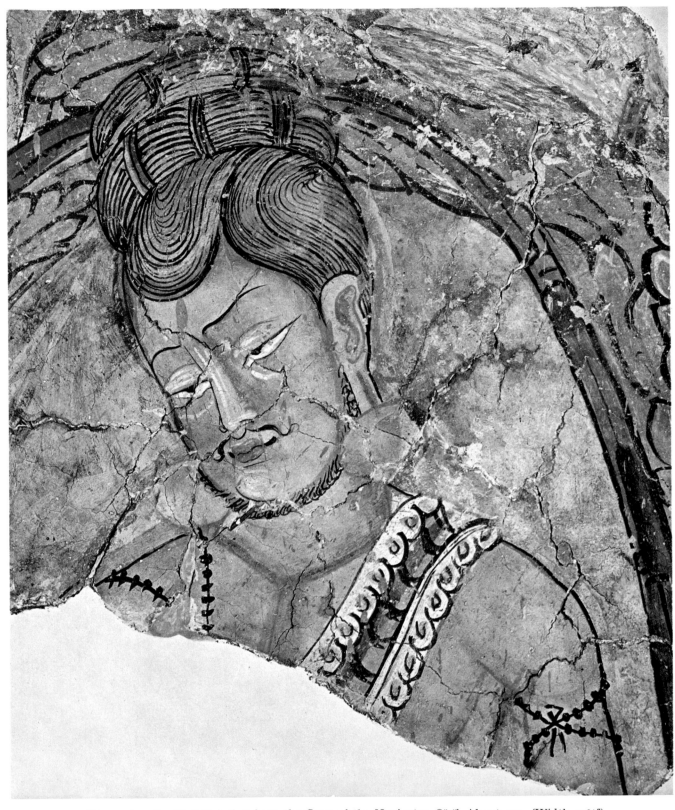

Young Ascetic. Wall Painting from the Cave of the Navigator, Qïzïl. About 500. (Width 13¾″)
I B 8389, Indische Kunstabteilung, Staatliche Museen, Berlin.

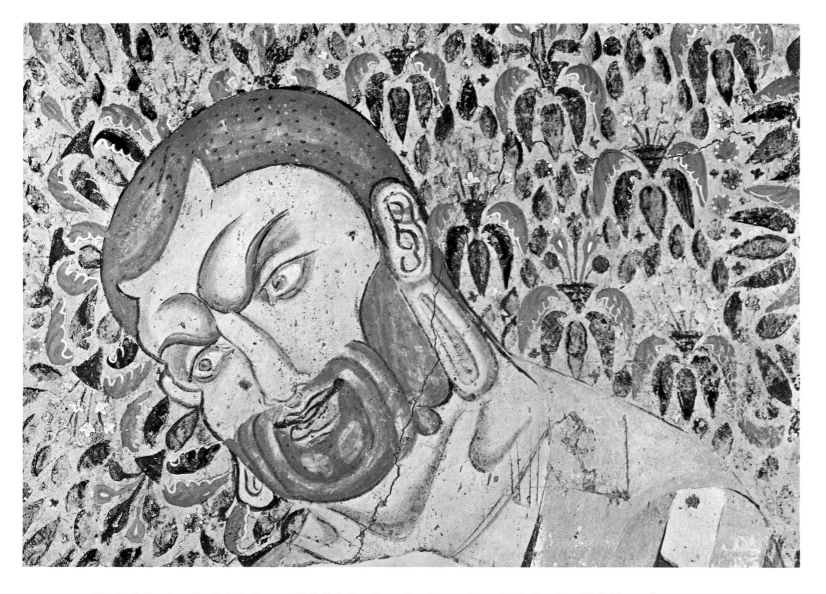

Head of the Ascetic Mahākaśyapa. Wall Painting from the Large Cave, Qïzïl. 600-650. (Height 15¾")
I B 8373a, Indische Kunstabteilung. Staatliche Museen, Berlin.

These reflect a growing taste for this type of figure, often carried to extremes; ascetics and monks become mere skeletons wasted by long mortification of the flesh. Their Illustration page 76 anatomical structure becomes a recognizable convention contrasting with the ordinariness of their fellows and the ostentatious wealth of the aristocratic donors.

The motifs of the skeleton and of the human body reduced to a skeleton are of classical inspiration, the former coming perhaps directly and the latter by way of Gandhāra. They occur a great deal in the painting and sculpture of Kučā as well as in the less important sculptures of Tumšuq, for example in the macabre dance of the nude woman with a skeleton and in the picture of a monk in meditation before a skull. Illustration page 68

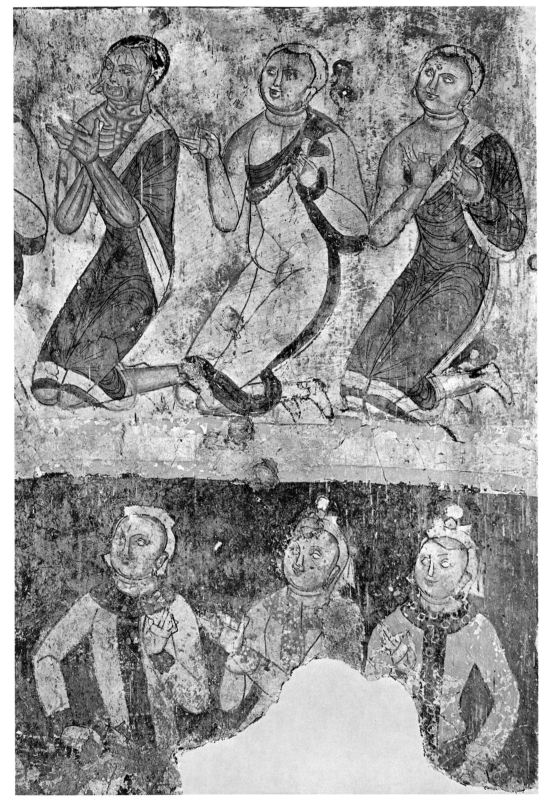

Monks and Ascetics (above) with Donors (below). Wall Painting from Qïzïl. 600-650. (Height 21⅞″)
I B 8372b, Indische Kunstabteilung, Staatliche Museen, Berlin.

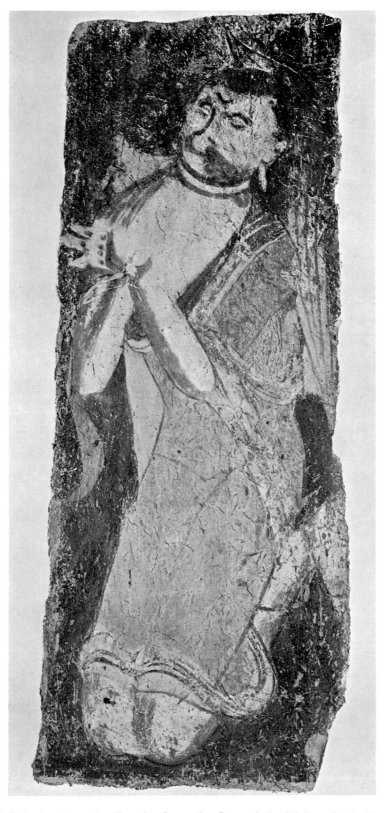

Kneeling Monk. Wall Painting from the Temple above the Cave of the Niches, Qïzïl. About 600 (?). (30½×11″)
I B 8487b, Indische Kunstabteilung, Staatliche Museen, Berlin.

Illustration page 68 The latter, one of the finest of all the Kuča paintings, is outstanding for its powerful style and can be assigned, in comparison with the other paintings in the Cave of the Navigator, to the first phase of art in the Kuča area. It is entirely free from those stylistic and schematic conventions expressive of local taste which abound elsewhere, alike in the structure of the larger compositions, in the conception of space and in various lesser Illustration page 73 details. Thus the group of swimmers in the same cave is far removed in style from the figure of the monk, just as in the Ajaṇṭā paintings we find in a single composition stylistic differences reflecting the personalities of different artists. The elongated eyes of the swimmers, the stylized swirls of the water (with precedents in the Mathura sculptures: the rushing wind in the Valahassa Jātaka on the stūpa balustrades), and the part played by linework—all show Indian influence. We would not suggest any date for Illustration page 68 the monk in meditation but would emphasize that the Kuča style was developing from an Indianizing phase much concerned with relief towards a flatter, more stylized design. The Indian component apart, this development resembles that of Iranian art in the Sassanian period, and a similar evolution can also be seen in other artistic movements.

Nevertheless the art of Kuča remains distinct from the others in its conception Illustration page 81 and treatment of space. The figures of the goddess and the celestial musician who accompanies her belong to the second phase, in spite of many Indian reminiscences in both the iconography and the composition. This work is among the most beautiful and best known of all the Kuča paintings. It takes its place in a figurative style which, though owing much to the achievements of India, ultimately departed from them quite markedly; its representation of space, above all, is very different, being obtained in part by means of decorative devices. Its typical rendering of space is against a background punctuated by stellar motifs, a rain of falling flowers and with them vague suggestions of fruit and petals. The subject of the picture, goddess and musician, as well as the attitude of the two female forms under a tree in blossom, enhance its unity. So does the harp encircling them in a wide double curve reaching into the nimbi, decorative motifs of a geometric-abstract order, further reinforcing the essential unity. On the other hand the elliptical lines of the great pendant necklaces create an illusory sense of volume and of space, without however flattening the figures, one of which would otherwise merge with the background because of its colours.

Such achievements are born of an uncommonly developed decorative sense and of a conception of figurative space far removed from that of India. Furthermore, there can sometimes be found in the school of Kuča fantastic landscapes which take their rhythm from the patches of colour formed by the figures, and which have much in common with similar compositions at Tun-huang. In other works the picture surface is divided into a network of geometric motifs, almost lozenges. Of classical origin, this device was taken up at Tun-huang and had great success in early Islamic art. Finally, as distinct from Indian practice, architectural features appear only as a background for the figures, without enclosing or framing them. At Kuča, attempts were made at the scientific rendering of perspective and the quasi axonometric construction of towers and portals whose receding lines, though drawn empirically, converge with perfect coherence.

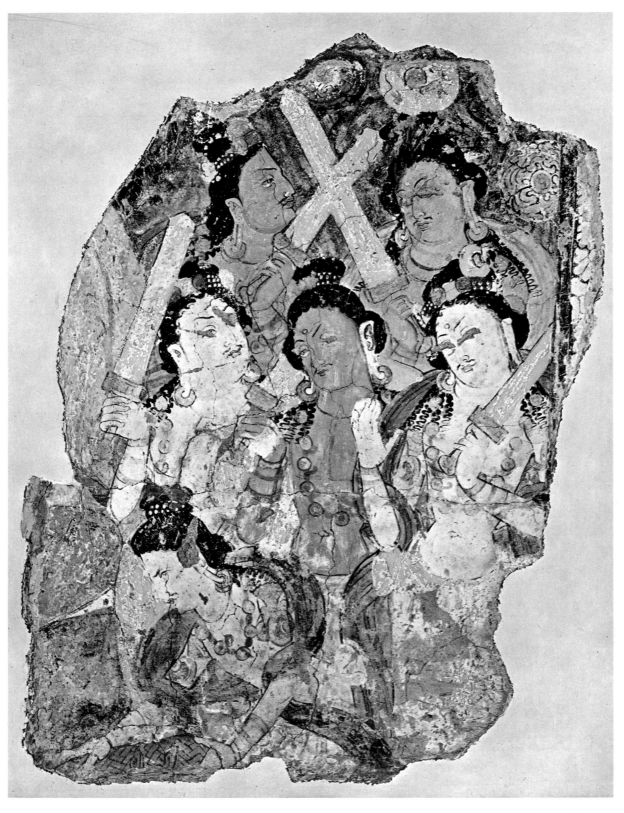

Figures armed with Swords. Wall Painting from the Peacock Cave, Qïzïl. About 500. (c. 22×17")
I B 8842, Indische Kunstabteilung, Staatliche Museen, Berlin.

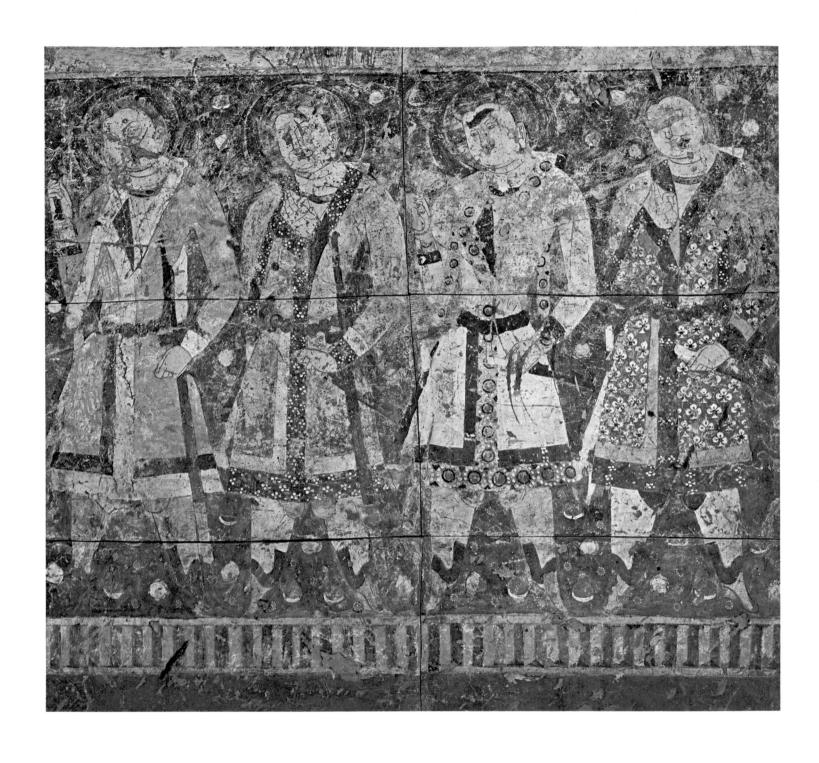

Donors. Wall Painting from the Cave of the Sixteen Sword Bearers, Qïzïl. 600-650. (Height 63")
I B 8691, Indische Kunstabteilung, Staatliche Museen, Berlin.

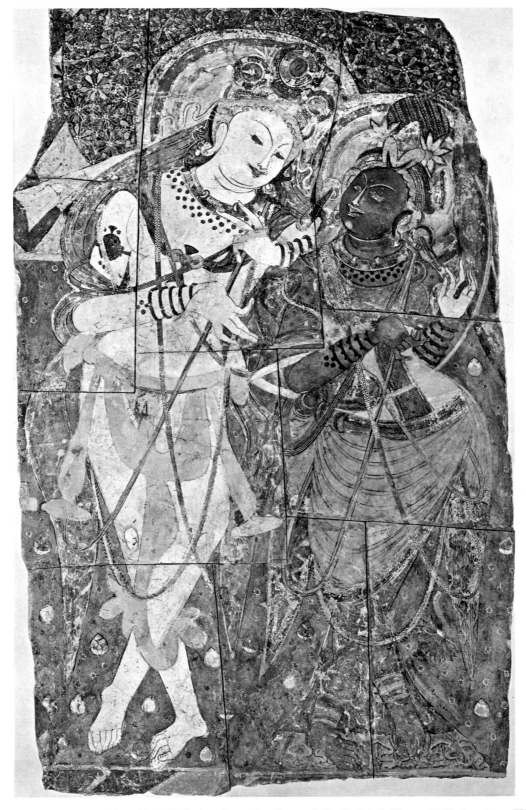

Goddess and Celestial Musician. Wall Painting from the Cave of the Painted Floor, Qïzïl. 600-650. (Width 53″)
I B 8420b, Indische Kunstabteilung, Staatliche Museen, Berlin.

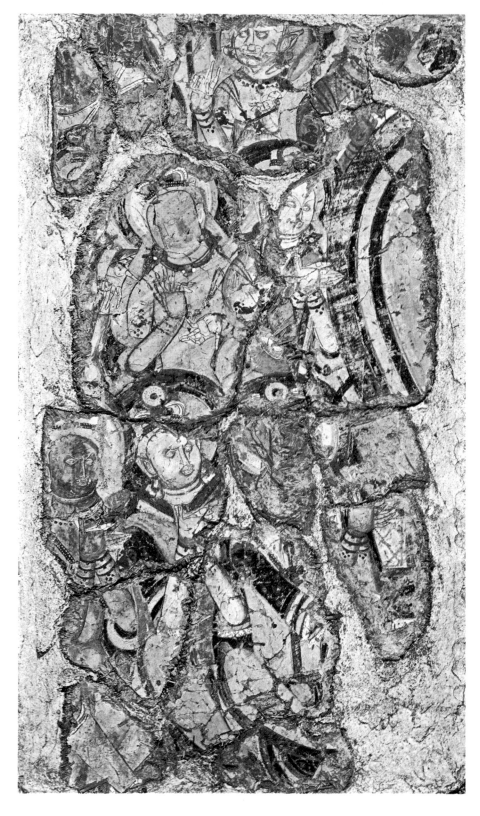

Scene of Worship. Wall Painting from the Cave of the Temptations (?), Qïzïl. 600-650.
National Museum, Tokyo.

Yet in the same work such architectural features may also serve only to ensure the harmonious distribution of space in important scenes; then the receding lines are no longer governed by the laws of perspective. In the first phase figures are often aligned in superimposed registers in the manner of the Gandhāra bas-reliefs. The alternation, or rather the simultaneous use of frontal, three-quarter and profile images, gives these works a characteristic vivacity associated with a special sense of space. This arrangement is found in the "Figures armed with Swords" and is quite different from the calculated regularity, reminiscent of Byzantine art, of the "Donors" in princely attire.

Illustration page 79
Illustration page 80

Between the first and the second styles therefore there is a real difference, a sort of bilingualism, not only in regard to colour but also to space. In reality the gamut of colours and above all the ways of using them are subordinated to the dominant conception of space and of volume. So we see a slow transformation of taste taking place in the course of successive experiments and intermediate phases. Edifying narratives and symbolic compositions get farther and farther away from reality in the direction of allegory —a trend corresponding to the movement of Buddhist thought, which was steadily tending towards mysticism. This was in line with developments both in religious thinking at Kučā and in the social structure, for the progressive extension of Iranian and Chinese influence must reflect great modifications of that structure within a relatively short time. Nevertheless, all the components of that art, whether recently imported or of long standing, were elaborated anew during the second phase in terms of original native taste in works that were more assured and more coherent.

The elongation of the figures, which occurred at various times over a wide area including northern China, part of the Gandhāra region and Sogdiana, naturally reappears here. At Kučā, however, it is of different inspiration. It is not mystical as with the Wei, nor do we find the arabesques and the almost plant-like elongation of the Pjandžikent paintings. It is quite simply a change in the proportions of the body, idealized in the Indian manner. At the same time there are archaic reminiscences, especially the position of the hands, almost in profile, clasped in prayer and the frontal rendering of the figures. These are highly stylized, with a very keen decorative sense, and show exceptional skill in composition and perspective. The same skill comes out in much more complicated compositions, as for example in one of the edifying episodes of the Avadāna of Rūpāvatī. If the figures here are much less elongated, the perspective and figurative elements remain much the same, as can be seen in the legs of the woman with the child and in the characteristic attitude of the Bodhisattva.

Illustration page 85

Illustration page 82

Illustration page 84

Painting must have been one of the principal forms of expression at Kučā. Even small objects were embellished with paintings which show a highly developed taste for drawing and the decorative use of colour. Alongside of the more important compositions, we find painted tablets and reliquaries both carefully executed and of high quality. The iconographic and stylistic features of the reliquary in the Kimura Collection, Tokyo, reflect faithfully the composite nature of the art of the Kučā region. On the casket lid the peacocks holding streamers in their beaks and the large pearly medallions take us back to the world of Iran, as do the same motifs in wall paintings. On the other hand

Illustrations pages 86-87

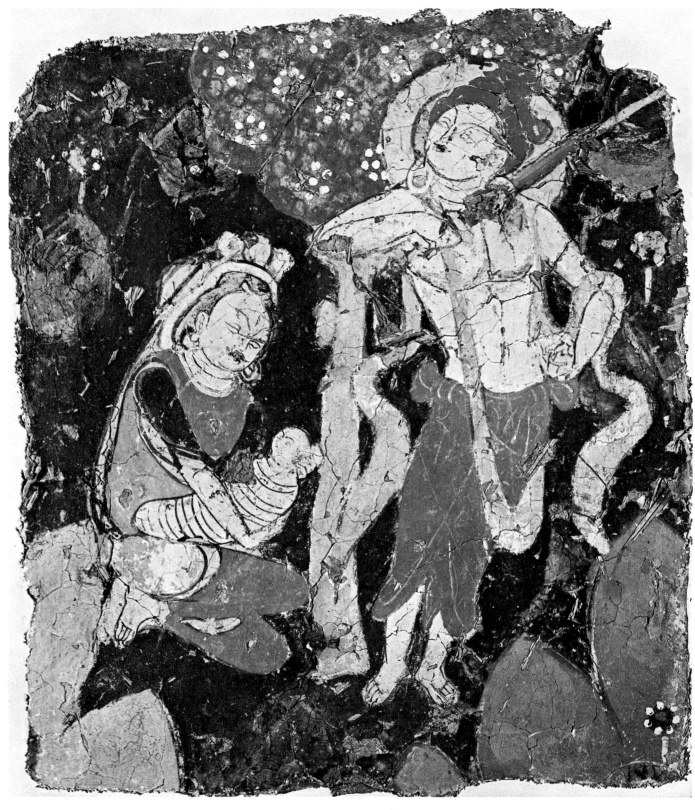

Avadāna of Rūpāvatī: The Sacrifice of the Bodhisattva (?). Wall Painting from the Cave of the Frieze of Musicians, Qïzïl. 600-650. (12×10¼″) I B 8390, Indische Kunstabteilung, Staatliche Museen, Berlin.

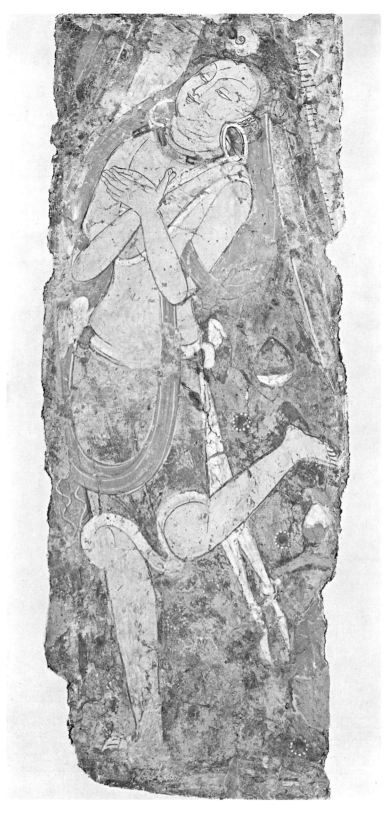

Young Brahman. Wall Painting from the Third Earlier Cave, Qïzïl. 650-700. (31¾×11¼")
I B 9030, Indische Kunstabteilung, Staatliche Museen, Berlin.

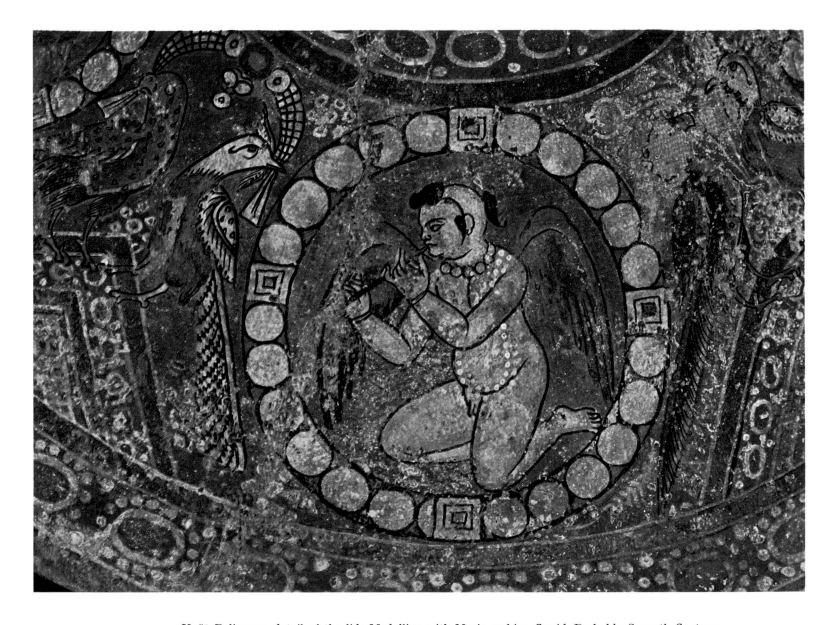

Kučā Reliquary, detail of the lid: Medallion with Music-making Cupid. Probably Seventh Century.
Terizo Kimura Collection, Tokyo.

Illustration above the little winged cupid, playing a flute-like instrument, also decked out in a pearl necklace, irresistibly recalls in its exceptional iconography similar work at Mirān. So, too, the almost shaven head and the long whiskers like halves of leaves also appear in a Gandhāran bas-relief from Sahri Bahlol, formerly in the Guides' Mess at Hoti Mardan and now in the Peshawar Museum. There are analogies to this type of shaven head, though somewhat uncertain, among the Begrām ivories (Stool X, drawing by P. Hamelin). The presence of a Gandhāran-Iranian element thus becomes evident. Though generally attributed to the seventh century, the Kučā reliquary might therefore be earlier.

Illustration below

The sides of the reliquary show masked men dancing. The repeated appearance among the dancers of the hare mask, alternating with demon and bird masks, makes it clear that this is a ritual-magic dance, funerary in character, peculiar to the Kučā region and possibly reminiscent of Shamanism—which adds to the interest of this scene. It forms a notable precedent, heralding similar dances which later developed among the Western Turks.

In the attempt made here to interpret the whirling movements of the dance, Iranian influence appears in the alternation of frontal and profile representation of the figures, and in the position of the dancers' legs similar to that of some of the dancing girls in the temple of Harwan, in Kashmir, which was also greatly influenced by Iran. In any case this reliquary, an exceptional work in the output of the Kučā painters, raises a whole series of questions concerning the persistence of Gandhāran forms, the interpretation

Kučā Reliquary, detail of a side panel: Masked Dancers. Probably Seventh Century.
Terizo Kimura Collection, Tokyo.

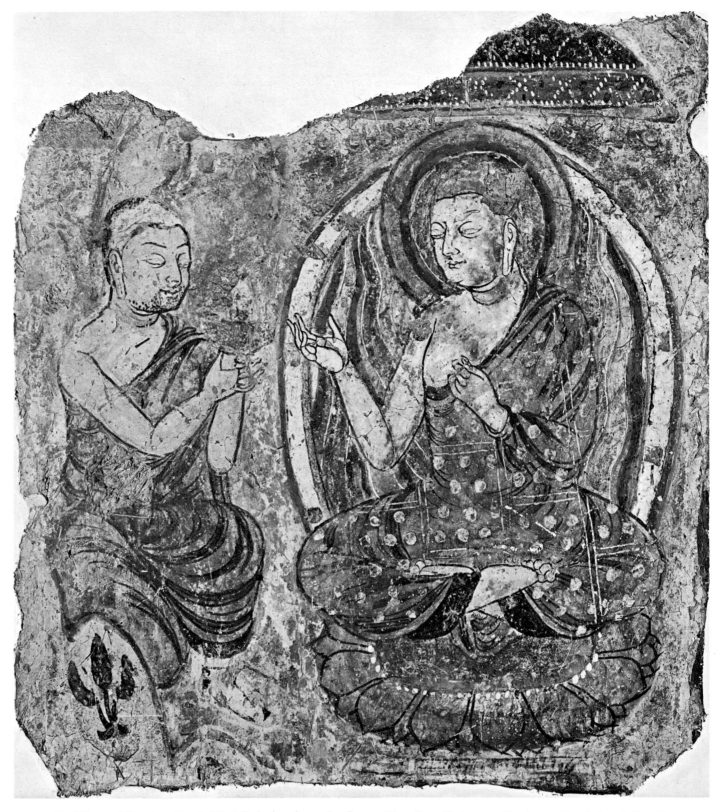

Buddha and Praying Monk. Wall Painting from the Cave with a Low Entrance, Qumtura. About 650. (18×16″)
I B 9024, Indische Kunstabteilung, Staatliche Museen, Berlin.

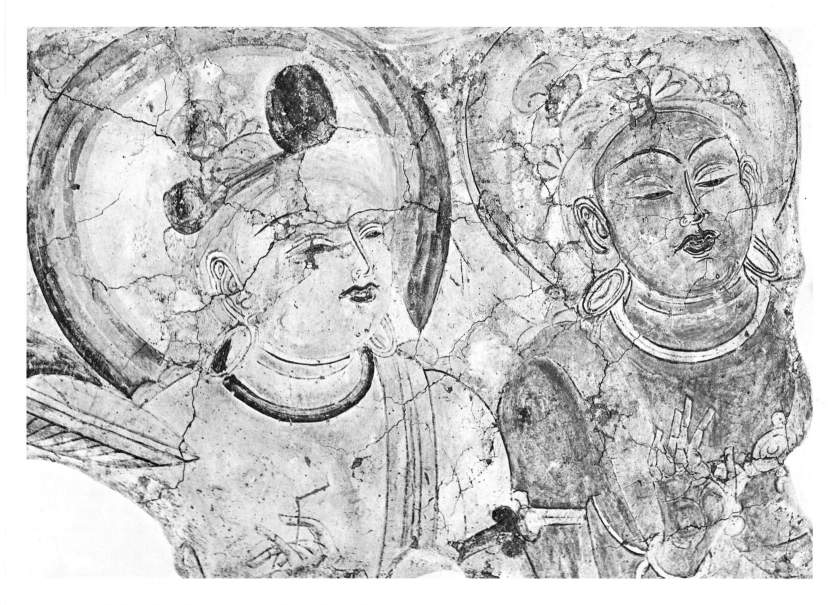

Divinities of the Tuṣita Heaven. Wall Painting from the Cave of the Apsaras, Qumtura. Eighth Century. (Height 18⅛″) I B 9021, Indische Kunstabteilung, Staatliche Museen, Berlin.

to be put on the Iranian component, and the very value of the pictorial activities of Kučā (indeed of Central Asia as a whole) in view of the scarcity of materials available for artistic purposes and of the specific sensibility of the region.

Our brief survey of painting at Kučā would be incomplete if we neglected the complex phenomenology of Qumtura. Painting went on longer there, forming a third phase, one marked by Chinese influence. In that part of the Qumtura production which corresponds to Qïzïl we find stylistic characteristics which add considerably to the data available for the study of art in the Kučā region. At Qumtura there are temples and shrines hollowed out of the rock and one temple built in the open air. This site must

Monks or Disciples. Wall Painting from Ming-oï XIII, near Šōrčuq. Eighth-Ninth Centuries (?). (Width 27½″)
18. MI. XIII 10, Collection of the National Museum, New Delhi.

stamp on its very beautiful works than on similar ones at Šōrčuq and Qarāšāhr, where for the most part they survived in unimportant ways. There is however one exception to note: the figures are set out in superimposed registers (but with the laws of perspective reversed, since the figures in the front row are smaller than those in the second), as we find them for example in one of the frescoes of the Ming-oï ("thousand caves"), four miles north of Šōrčuq. The Mongol faces of the ten disciples of the Buddha, their formal

Illustration above

structure which makes them look commonplace, and the emphasis on line belong assuredly to an art deeply immersed in Chinese usages; the only western echoes remaining are in the decorative designs of the fabrics, which are certainly of Sassanian inspiration. The religious and archaeological importance of Šōrčuq is beyond question. It can be seen in the surviving paintings and sculptures, sometimes of high quality, and still more in the many buildings, both those hewn out of the rock and others erected in the open air.

The geographical position of Šōrčuq made it a place of meeting and mutual influence for figurative currents from Kučā and Chinese influences from the east, while by way of a road joining the two main caravan routes came a Khotanese contribution, far from negligible, particularly in sculpture. Yet, in spite of the many foreign features absorbed by Šōrčuq, with pride of place given to those of Kučā, the local paintings have their

Female Donors. Wall Painting from Cave VII, Šōrčuq. Eighth-Ninth Centuries (?). (Height 8¾″)
I B 9127c, Indische Kunstabteilung, Staatliche Museen, Berlin.

In the first stylistic phase of painting at Turfān there was a slow decline of the classical Iranian and Indian characteristics which had penetrated into the region and been re-elaborated in the Kučean manner. These gave way before Chinese influence, which sometimes managed to modify even the common motifs of Buddhist iconography. On this process of Sinicization T'ang realism set a deep imprint, as a result of events leading to the region's becoming part of the Chinese empire. A Chinese official was installed in Kao-ch'ang as "Protector General and Pacifier of the West." Then came Manichaeism and a resumption of Iranian influence, more particularly in the art of miniature painting, while Nestorian Christianity added Iranian, Syrian and western elements. The work of this second Buddhist period was generally inferior to that of the seventh and eighth centuries, so harmonious and calligraphic, and tended towards the iconography of Tantric Buddhism.

By oscillating between Iranian and Chinese forms Turfān was in fact becoming, as René Grousset noted, a link between the tastes and tendencies of pre-Islamic Iran and aesthetic currents from eastern Asia. Its brilliant works were created in a region where, thanks to various historical factors, their different components could mingle and be fused with fuller intensity than elsewhere. Yet, whatever the Uighur contribution may have been—and it is the undoubted source of that disembodied purity of line so often found in Turkish art—the problems which art raises were solved in the Sino-Iranian creations of Turfān with a mastery of the very highest order.

The different phases of that complex art are differently rendered from one locality to another. Paintings in monastic centres of the same period like Bäzäklik and Murtuq show different degrees of Chinese influence. Murtuq, for example, retained many Iranian and Indian characteristics and was directly influenced by Kučā and Šörčuq, owing perhaps to the doctrinal attitude of its monks, with their leaning towards Mahāyāna Buddhism. At Bäzäklik, on the contrary, where a decided Tantric tendency prevailed, Chinese influences range so wide and deep as to constitute an artistic and iconographic phenomenon even more complex than at Qumtura; developments at Bäzäklik, moreover, followed other lines and included experiments of an intermediate kind (those in particular of the Qarāšāhr area). Finally, Qočo offers the most complete evidence of Manichaean and Nestorian influences, and also of the different phases of the interaction of Chinese and Iranian cultures, favoured by religious factors and confirmed by Iranian features in the architecture.

Among sites of lesser importance are Sängim and Toyuq. In the Sängim area the pictures in temples hewn out of the rocks, or sheltering behind them, show a peculiar mingling of Indian, Iranian and Chinese currents, whereas at Toyuq, the imposing remains of rock temples show only the usual Sino-Iranian features, but at the same time the rich original qualities resulting from their fusion.

Turfān painting up to the seventh and eighth centuries draws its inspiration on the whole from the west. That comes out, for example, in the head of a Buddha in a wall painting from Qočo. Here the effort to produce an illusory effect of relief by means of both line and chiaroscuro is so obvious as to suggest the hand of a painter-sculptor.

Illustration page 97

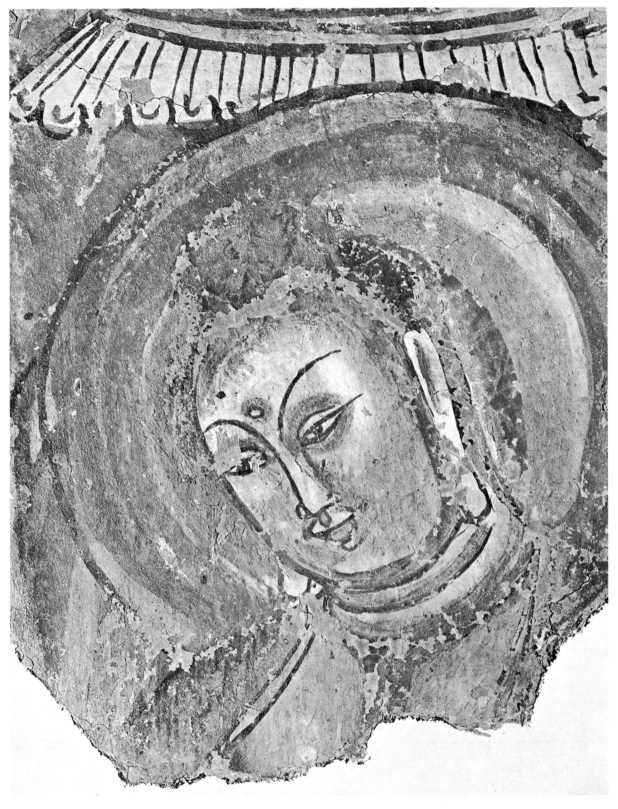

Buddha beneath a Canopy. Wall Painting from Qočo. Seventh-Eighth Centuries. (Height c. 8″)
I B 8731, Indische Kunstabteilung, Staatliche Museen, Berlin.

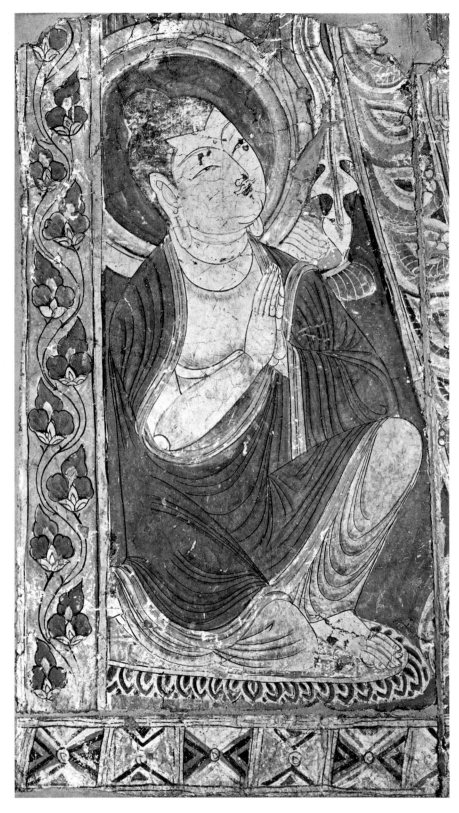

Kneeling Buddha. Detail of a Wall Painting from Shrine XII, Bäzäklik. Eighth Century.
(Average width 21½″) BEZ. XII, A-B, Collection of the National Museum, New Delhi.

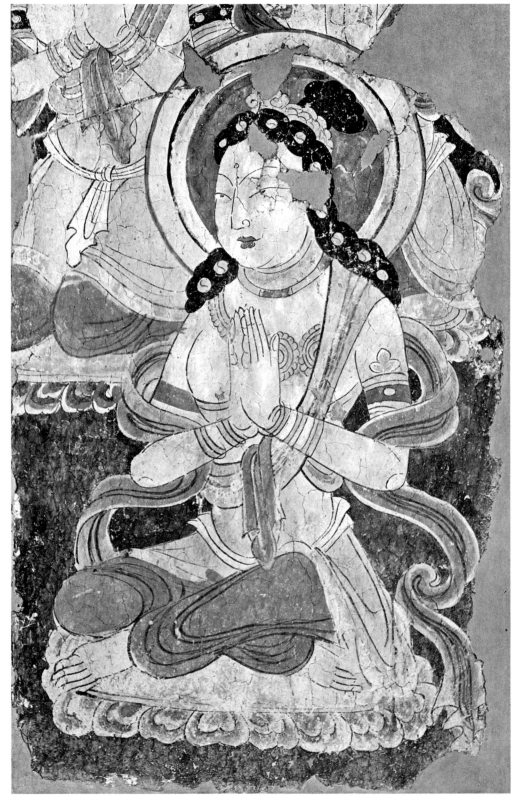

Offering Scene: Deva in Adoration. Wall Painting from Shrine I, Bazäklik. Eighth-Ninth Centuries. (Average width 17¾″) 3. BEZ. I, M-N, Collection of the National Museum, New Delhi.

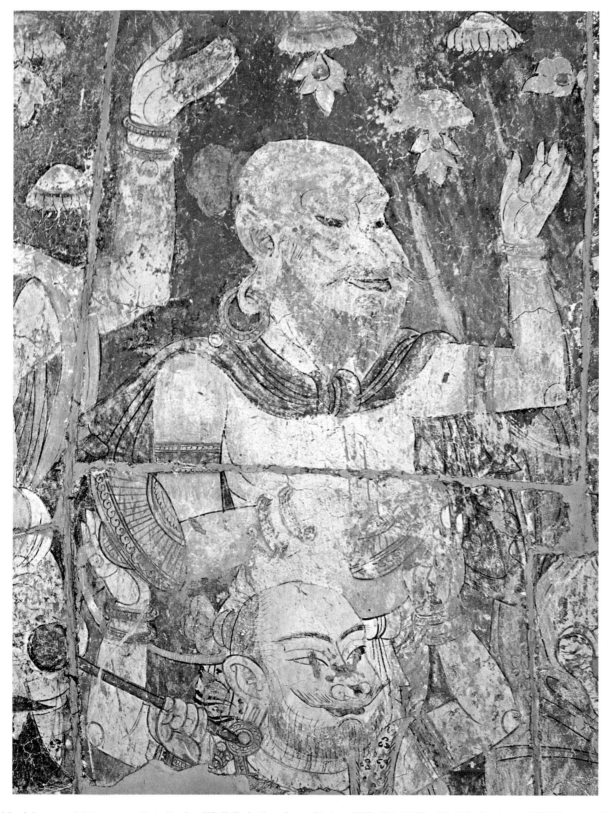

Musicians and Mourners. Detail of a Wall Painting from Shrine XII, Bäzäklik. Eighth Century. (Width c. 19½″)
BEZ. XII, A-B, Collection of the National Museum, New Delhi.

In the head beneath a canopy, the bold strokes of the arching eyebrows, the shape of the eyes, the dress and other details, it closely resembles in structure and iconography the sculptures of Šōrčuq. The connection of this work with western figurative tendencies comes out in many ways. Illustration page 97

On the other hand, in another figure of the Buddha, very like this in iconography, it is Chinese influence that stands out. A slightly later work, it is part of a large composition from Bäzäklik. There is no attempt whatever at illusory relief. Instead we have a clear incisive design like pen work by a virtuoso, though many similarities remain apparent. There is the same head-dress, the same high curve of the eyebrows in two strokes, the same treatment of the nose and the folds of the neck, the same elongated eyes (undoubtedly Chinese in the Bäzäklik Buddha) and the same way of treating the dress. None the less the difference of style between the two works is so great that the iconographic resemblance remains at first sight almost unobserved. Only the relief noticeable in some of the folds of the Buddha's dress, and in the scarves belonging to the larger figure and here brought out by means of colour, reveals a western element of probably classical origin and constantly recurring. The structure of his face is repeated in other works of the Bäzäklik group as, for instance, in the worshipping *devas*, richly bejewelled in a scene of gift offerings to the Buddha. The artist's obvious effort to endow each figure in the scene with a personality of its own fails to lessen the lifeless fixity of the stereotyped faces. Illustration page 98 Illustration page 99

Other pictures present a striking contrast, thanks to their realistic characterization of different types of figures. A wall painting in Shrine IX shows people mourning at the death of the Buddha. Among the dignitaries, princes and sovereigns it is easy to distinguish by their faces and dress between Arabs, Iranians and Chinese, and their presence effectively demonstrates the universality of the Buddhist communion. If in this fragment facial features are sometimes involuntarily accentuated to the point of caricature, in others they become frankly grotesque. A group of musicians, demi-gods perhaps, is a case in point. Their attitudes, some with mouth agape singing a barbaric song, suggest the rapid rhythm of the music. Similar portrait patterns recur and have some of the characteristics of the terracotta funerary figurines *(ming-ch'i)* of T'ang China. Illustration page 110 Illustration page 103 Illustration page 100

When, however, there is a real attempt to produce resemblance to a model the result can be a portrait of gently solemn nobility, as in the ex-voto painting on silk of an Uighur prince in a rich robe of Chinese silk, in spite of the disproportion in the small squat body. Interest in the structure of the human body seems in fact to be giving way to a deeper concern for significant expression, for physiognomy and for studied detail in the head-dress. This is evident in pictures of Uighur princes and princesses, hieratic figures in a stiff worshipping posture, sometimes ranged in rows apparently ornamental, each carrying in the hand a flower as an offering and with an inscription showing their identity. Interest in the anatomical structure of the figures is diminishing. They are draped in ample, loose-fitting garments which envelop rather than mould the form of the limbs, thus concealing altogether the harmony of their proportions—a complete contrast to the Buddhist tradition in edifying sacred scenes. Illustration page 105 Illustrations pages 106-107

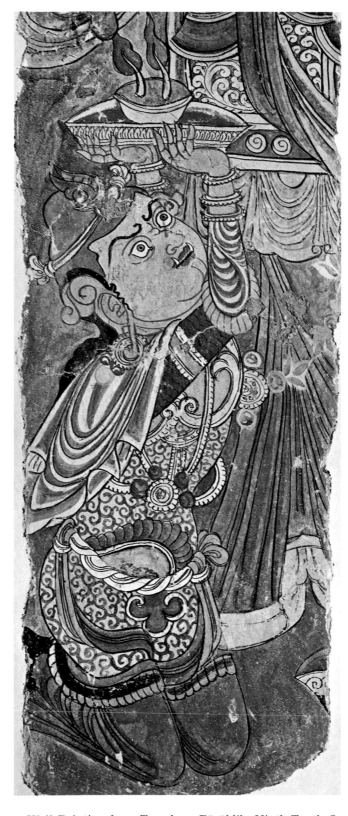

Demon with a Lamp. Wall Painting from Temple 9, Bäzäklik. Ninth-Tenth Centuries. (c. 25×10″)
I B 6875, Indische Kunstabteilung, Staatliche Museen, Berlin.

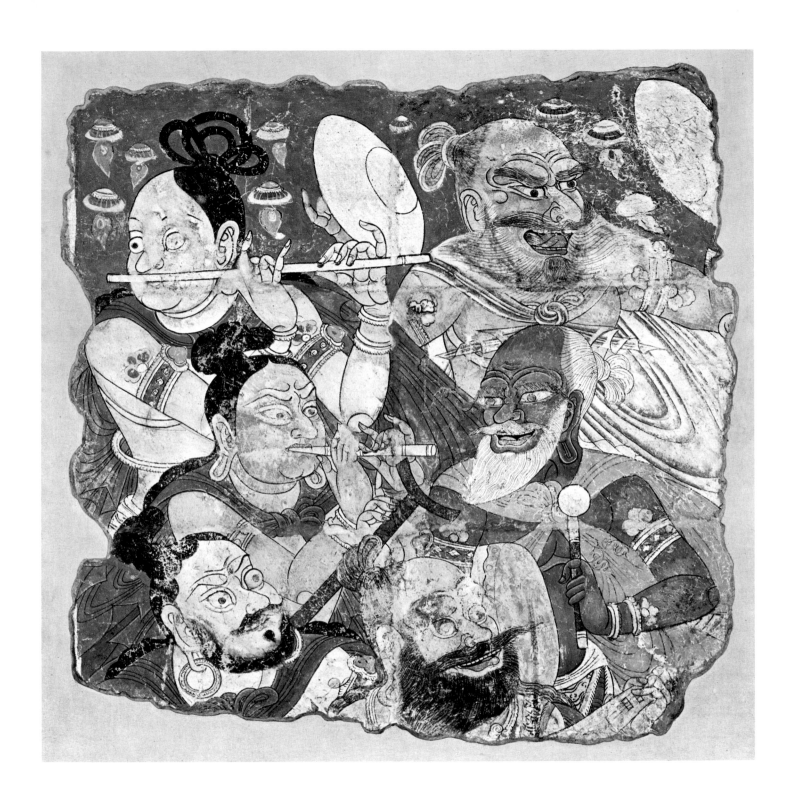

Musicians. Wall Painting from Bäzäklik. Eighth Century. Private Collection, Tokyo.

That apart, the Turfān artists' approach is very much in the spirit of all Far Eastern art and demonstrates the substantial agreement between Turkish and Chinese taste. An effort to render features—and character too perhaps—occurs oftener in portraits of men, although it is not entirely absent from women's. In the latter the faces are more stereotyped, the features very fine and the details finished as if with a calligrapher's pen. The art of portraiture, however, continued to be cultivated by some highly gifted artists, who carried it down to quite a late period.

Landscape painting reveals a very different spirit. The genre paintings common at Tun-huang are entirely lacking at Turfān. Architectural representations sometimes occur as incidental features of a picture, undoubtedly copied from actual buildings, but often with no direct bearing on the religious scene in which they figure. In general the occasional renderings of landscape leave reality for fairyland, and the stylized mountains follow Sassanian models transmitted perhaps by way of Kučā. A little more realism sometimes appears in trees or rocks, most of all in animals.

Illustration page 109 In one picture, a fragment showing a dragon leaping out of the sea or a lake, all these elements are combined in a strange vision. The expressive power of the monster itself, of pure Chinese inspiration, and the terror conveyed by savage nature, fit for such a creature and forbidden to man, render the apparition frightful. Iranian features, western in general (the rippling waters represented by scroll designs as at Qïzïl), mingle with others including Chinese elements and Chinese re-elaborations of western elements. Hence, although Chinese influence is very pronounced at Bäzäklik too and that of Iran greatly reduced, the latter's has not entirely disappeared. There remains however a spirit of faery far from the measured mastery of the Chinese court painters, and at the same time more concrete and descriptive than the fantastic compositions with rhythmic perspective of Tun-huang. It is undoubtedly Buddhist fantasy further developed in Central Asia that inspired these creations in which typological and iconographic elements from many civilizations meet and mingle.

Illustration page 108 Thus in the demon figures drawn in Indian ink, an illustration from an Uighur scroll, although the strokes are more emphatic than usual in contemporary paintings in China, the technique would prove the work indubitably Chinese. The conception of the monster, however, is Indian and the anatomical structure suggests a Gandhāran origin.

All the same, this grotesque yet powerful figure taken as a whole does not appear to be completely Chinese, since the Indian and semi-classical touches in it are recast in ways we can call Central Asian and hence Turkish; it has the neat curves and descriptive precision found in so many other Buddhist visions of the terrifying and infernal. But because it is a miniature and an illustration, and also because of the technique, no more is to be expected of it. It cannot achieve the precision of detail we find in the wall paintings and in the terrifying demon figures of Tantric Buddhism with their brightly coloured Illustration page 102 draperies and elaborate jewellery, like the kneeling figure holding up to the Buddha a precious lamp with two flames. This expresses very clearly that sense of the monstrous which, in its schematic repetition of certain formulae, becomes in reality more grotesque than terrifying.

Uighur Prince. Detail of a Banner found at Qočo. Ninth Century (?). (Width c. 14″)
I B 7323, Indische Kunstabteilung, Staatliche Museen, Berlin.

Uighur Prince. Wall Painting from Temple 19, Bäzäklik. Eighth-Ninth Centuries. (Width 8⅜″)
I B 8381, Indische Kunstabteilung, Staatliche Museen, Berlin.

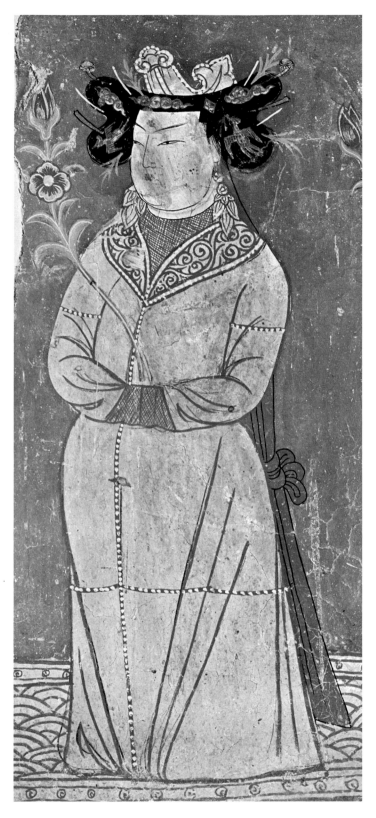

Uighur Princess. Wall Painting from Bäzäklik. Ninth Century. (Height 21¼″)
I B 6876b, Indische Kunstabteilung, Staatliche Museen, Berlin.

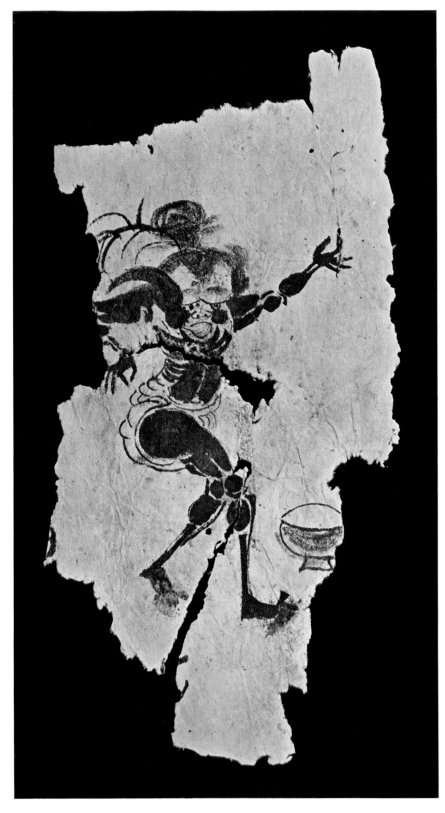

Demon. Fragment of an Uighur Scroll. Indian Ink on Paper. From Area X, Qočo. Eighth-Ninth Centuries.
(Height 6½") I B 4951, Indische Kunstabteilung, Staatliche Museen, Berlin.

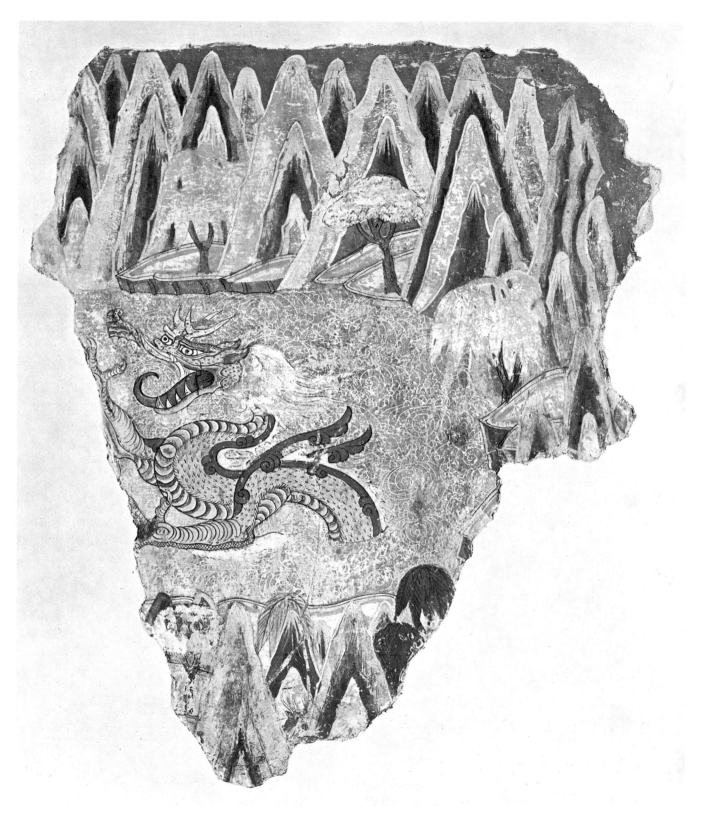

Dragon leaping out of the Water. Wall Painting from Temple 19, Bäzäklik. Ninth-Tenth Centuries. (Height 25⅛″)
I B 8383, Indische Kunstabteilung, Staatliche Museen, Berlin.

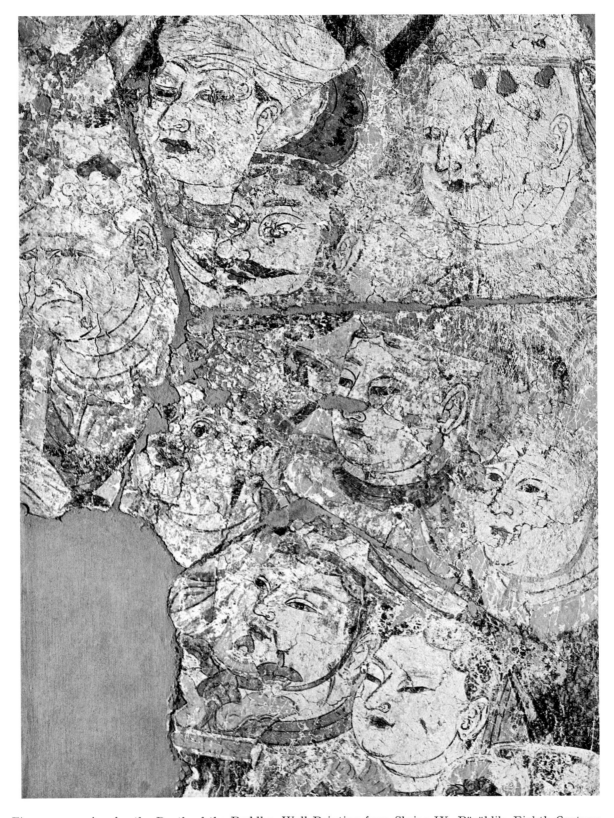

Figures mourning for the Death of the Buddha. Wall Painting from Shrine IX, Bäzäklik. Eighth Century.
(Width c. 23½″) 5. BEZ. XI, A-C, Collection of the National Museum, New Delhi.

Yet we need not conclude that all the miniatures of the region keep to one style, an adaptation of the Chinese taste for Indian ink and the patch. On the contrary, most of them were richly coloured and anticipated in many of their features the miniatures and ceramics of Islamic art, particularly those of Iran. Their way of treating the human form, the structure of the face and the stylized draperies are still to be found in the ceramics of Saveh, in Ilkhanid art and even later. There was thus a backwash into Iran of a current that started out from that country. It had already left its mark on the Uighur miniatures of Turfān and borrowed from the Turks their instinctive inclination for pure line and minute detail. With these was combined a Chinese element, not very evident at first sight yet essential, which developed figurative and perspective patterns that were to be long in favour. Even when the iconography became Manichaean and, by religious affinity, Illustration on title page adopted Buddhist or other Indian forms which it promptly rearranged on new lines and with new values, the encounter of the cultures of India and Iran in the region of Turfān remained abundantly clear. And from that encounter was born a particular stylistic idiom which, moving westwards, reacted on Islamic art with profound effects.

The Nestorian wall paintings of the "Christian" temple of Qočo reveal a completely different style. The confusion of scenes crowded with figures in some Manichaean miniatures is replaced by a measured, hieratic rhythm which leaves between the figures enough Illustration page 113 space for each to have its own individuality, almost its own atmosphere. Symbolic proportion continues with more emphasis, while Iranian and Syrian features from the west grow more marked in the vestments and elaborate head-dress of the priests, who come to resemble those of our own world. In "Palm Sunday," for example, the priest Illustration page 112 standing in front of a row of the faithful has western features, while the Mongol faces of the worshippers, with their variety of attitude and expression, are rendered with a naturalism almost entirely free of Chinese influence. There is an effort to portray the features of the different races through stylistic ways and devices foreign to the Chinese methods found elsewhere in Turfān art. The figure drawing, however, retains all its subtlety. At the top of the picture, the leg of a horse (which has now vanished) recall certain Khotanese compositions from Dāndān Öilüq, an analogy suggesting that in the two areas the problem of rendering space was being tackled in similar ways.

Nestorian art, in short, kept to a particular Iranian tradition which remained in closer contact than any other with the Syrian and Byzantine works of the west. It appears to stand apart from the Buddhist and Manichaean traditions and probably reflects the aspirations of a closed, isolated community. In any case it is further evidence on the one hand of the plurality and diversity of artistic life in Turfān and, on the other, of the varying conceptions of man and the world held by different religious communities and sects. The figurative space of this art, rhythmically organized against a neutral background, even if of Khotanese origin (which is doubtful), is actually nearer to Byzantium and Ravenna than to other productions of the Turfān area at that time, whether Buddhist or Manichaean.

That too is why, as we said at the outset, Turfān raises a very real problem. Many artistic tendencies there converge. The type of drapery, which is reduced to the broad

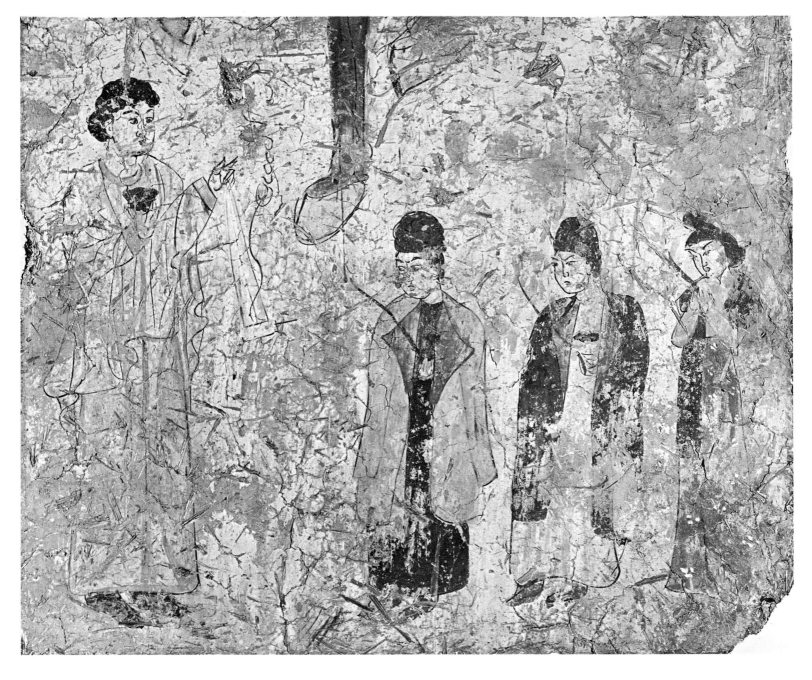

Palm Sunday (?). Wall Painting from the Nestorian Temple at the Eastern Gate, Qočo. Late Ninth Century. (23½×25″) I B 6911, Indische Kunstabteilung, Staatliche Museen, Berlin.

concentric folds often used at Pjandžikent, is obviously connected with the art of Sodgiana, and certain historical facts confirm this. It is, however, the complicated religious developments of the region which determined to some extent its style. At the root of the deep gulf separating the Buddhist compositions of Bäzäklik and Murtuq from those of the "Christian" temple at Qočo is the contrast between two mystic convictions equally deep

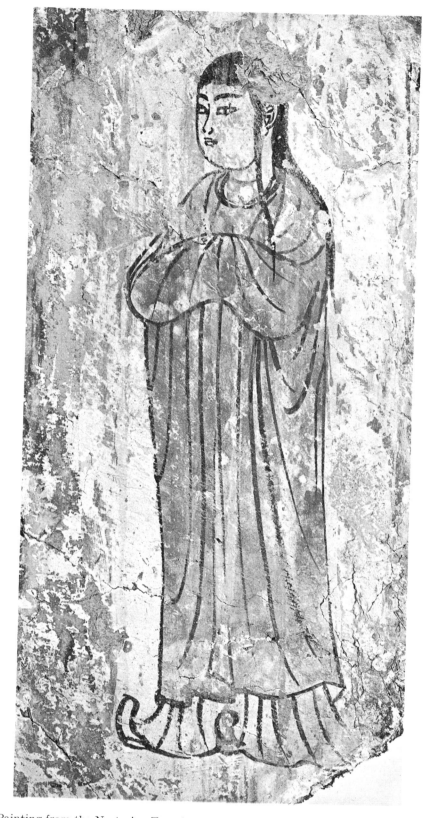

Worshipper. Wall Painting from the Nestorian Temple at the Eastern Gate, Qočo. Late Ninth Century. ($17\frac{1}{8} \times 8\frac{1}{4}''$)
I B 6912, Indische Kunstabteilung, Staatliche Museen, Berlin.

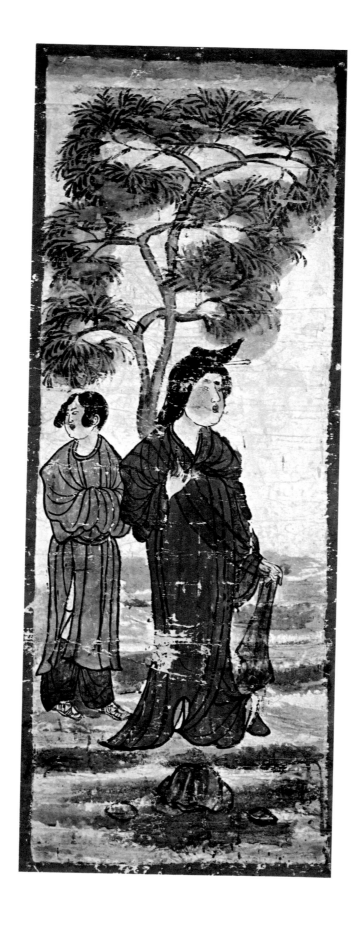

touches that surpass and in a sense overwhelm the Chinese elements, which are however unmistakably there. The meticulous rendering of colour effects in both works is not Chinese but Central Asian. A noteworthy detail is the decorative function of the scarves and the long necklaces of Dhṛtarāṣṭra (the Lokapāla of the East) which at once brings to mind the similar devices found at Kučā and elsewhere. The facial features—described by Golubev as a cross between the Turco-Iranian horseman and the Chinese legionary— recall, without intentional caricature, the well-characterized figures of Bäzäklik, just as the rudimentary anatomy of the demon trampled underfoot has its counterparts in the wall paintings of the Turfān area—and not only there. Illustrations pages 116-117

Illustration page 116

These observations would apply equally well to the other picture. At the top is represented the paradise of a supreme Buddha situated over a pool linked to the world of phenomena and the infernal regions by three bridges (an Iranian echo of the Bridge of Souls); below is Kṣitigarbha, the divinity who intercedes with Hell's judges and is himself Lord of the Six Ways (the six conditions of rebirth), here symbolized by the little figures seated on the six scarves fluttering on each side of the god. The faces of the two monks and of the two Lokapālas above, the variegated nimbi, the perspective of the bridges, the very shape of Kṣitigarbha's eyes and the treatment of his robe—every one of these is foreign to Chinese tradition. That tradition comes back in full force, however, in the lion with the golden mane and in the figures of the judges of the lower regions with their curious head-dress. Besides, the extraordinary popularity of Kṣitigarbha locally, in such striking contrast to the decline of his cult in China and Japan, is evidence of the great independence of thought associated with the eschatological speculation characteristic of Central Asia. Illustration page 117

Finally, it is inevitable that works for popular consumption like the two thousand-armed Avalokiteśvaras painted on paper, that strange expression of a minor cult, should use iconographic formulae derived from India. But still more important is the fact of their being re-elaborated in Central Asian fashion, as is shown in the floral crowns, the plaited bows in the dress, the very structure of the bodies, an independent rendering of post-Gupta forms. That structure may have been due to the artist's desire to hark back to Indian works because of the special sanctity attributed to them, more particularly by foreign worshippers. But a spirit of concession to Central Asian taste remains evident in this work which, better than any other, testifies to the composite character of the art world of Tun-huang. Illustration page 120

There is then ample evidence of the continual give and take between China and Central Asia. It is found in the great cycle of Tun-huang paintings where frequent analogies with Kučā and Khotan can be seen and where the rhythmic rows of Bodhisattvas and donors recall those of Ravenna and Byzantine mosaics. There is further evidence in the characteristic scroll paintings and in the devotional pictures which, although frankly on the level of artisan work, yet maintain a fairly high standard of quality.

◀ Lady and her Maid beneath a Tree. Scroll Painting from Astāna (Turfān).
Eighth Century. (58¾×22½") Hakone Museum (Japan).

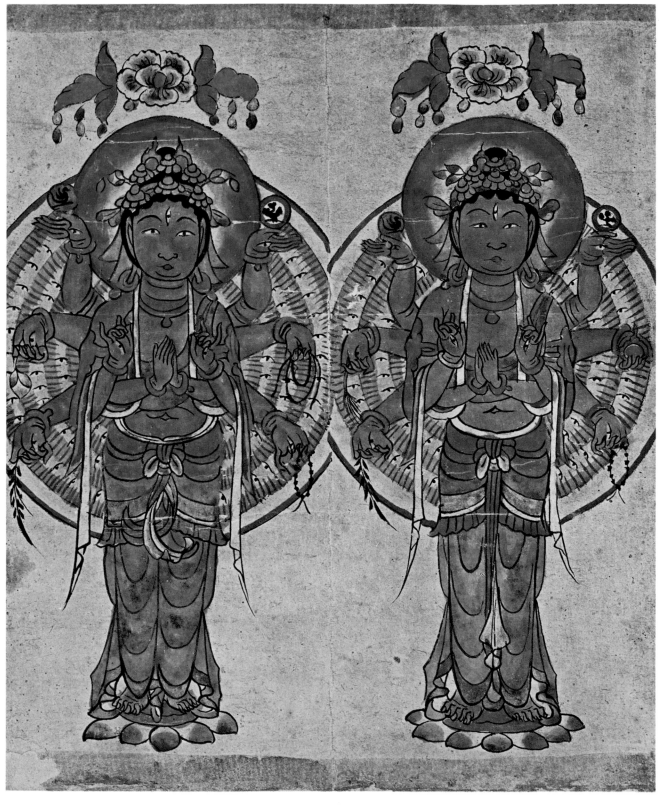

The Thousand-Armed Bodhisattva Avalokiteśvara. Painting on Paper from Tun-huang. Ninth Century.
(15×12¼″) Musée Guimet, Paris.

All this goes to show the extraordinary importance of the contribution made by Central Asia—a chapter apart in the development of art throughout Asia as a whole. China was not the only land to respond to that contribution, the fruit of a long process of creation and transformation. The school of Khotan, we have now seen, influenced aesthetic and iconographic developments in Tibet and earned the praise of some of the most distinguished of Chinese art critics.

From Turfān too, from Kučā and Pjandžikent, came motifs, trends and iconographic schemes that entered into the nascent art of Islam. They left a deep impression on Ghaznavid art, today seen to be more complex than hitherto supposed, on the Abbasid paintings of Samarra and on the Fatimid paintings in the Palatine Chapel of Palermo. Another beneficiary was Seljūk art, which of course contains a definitely Turkish element and is at the same time an obvious reflection of art forms already taken up in the Turfān area when Uighur taste had adapted itself to local and incoming trends. In Ghaznavid painting itself, however, the decorative use of the human figure, such as the rows of guards in the palace of Laškari Bazar, their proportions and the arrangement of the space between them come from Turfān; whether there is here a greater preponderance of Bäzäklik or of Toyuq features it is impossible to say. That Bäzäklik had contacts with the Moslem world we can see from pictures of people in Arab dress and one where a blanket thrown over a camel has an invocation to Allah written in Kufic characters.

From all these facts we can see how important a part was played by the art of Central Asia which, at an early stage, came to some extent into the stream of what Daniel Schlumberger has called the "non-Mediterranean descendants of Greco-Roman art." It subsequently gave birth to a series of independent movements which influenced and were influenced by the major civilizations of Asia.

Central Asia was in fact a melting pot, a ferment of interacting forces, yet its essentially eclectic art, so far from stifling native creative genius, rendered it more acute and enabled it to stimulate the surrounding areas. Thus its influence was felt not only in the nascent art of Tibet but also in the ancient Buddhist art of China, in much of Indo-Iranian art (with its different semi-Indian and semi-Iranian strains), and it played a conspicuous part, over a vast area, in the creations of Islamic art.

The historical interest of these works and their importance cannot be denied. Looked at from the critical and aesthetic angle, the enormous number of problems presented by the pictorial currents of Central Asia demonstrate the urgent need for research to be undertaken, both comprehensive and detailed. For the western world of art, with its own experience, problems and solutions, might profit from those of a world so profoundly different. We have seen how certain patterns and criteria current in western criticism are no longer valid when applied to Central Asia. What is striking there is the multiplicity of ways of rendering space and perspective in a world relatively homogeneous, socially speaking, and where an all-pervasive Buddhism was the religious force unifying a large part of Asia under the banner of its particular kind of humanism. Similarly the relation between sign and image, the use of light as the key to aesthetic creation, the artists' willingness to expound to the faithful in figurative terms metaphysical values otherwise

hard to grasp, and to offer them edifying examples—all this is remarkably close, even in style, to the art of Byzantium and that of our own Middle Ages. Productions of a very different order assuredly, yet having this in common: each operates in a civilization embodying a faith that seeks to enhance and clarify in its own way a metaphysical system involving the essential problems inseparable from the history of universal art.

More, however, than the extraordinary similarities between these works and our own Byzantine and medieval art, still more even than the role of intermediary in typological and iconographical matters between East and West (the role assumed over a long period by the art of Central Asia), what the modern spirit responds to there is rather the resourcefulness of these Asiatic peoples. It is exemplified in the rich variety in style and iconography invented by the artists of Sogdiana and Khotan, of Kučā and Turfān, in order to give material embodiment to a spiritual world, and this in the midst of warrior and trading communities operating in a pivotal area of continental Asia. Whether as products of an industrialized art or of the individual fancy of strong personalities, the painting of Central Asia is a brilliant page of the universal genius of art, a rich and suggestive creation posing problems without end. It deserves to be studied and appreciated by all who seek in the figurative arts not simply aesthetic enjoyment but the expression, clearer because free of language barriers, of eternal values and the spirit of man.

May the foregoing work enhance in some measure interest in works of art that seem to anticipate by about a millennium the modern aspiration towards a universal humanism. For the aesthetic sensibilities, on the one hand, of Asia and of the Hellenistic-Roman world and Byzantium and, on the other, of the Middle Ages and of Islam, find in that art a profound and unexpected integration.

Documents - Bibliography

General Index

List of Illustrations

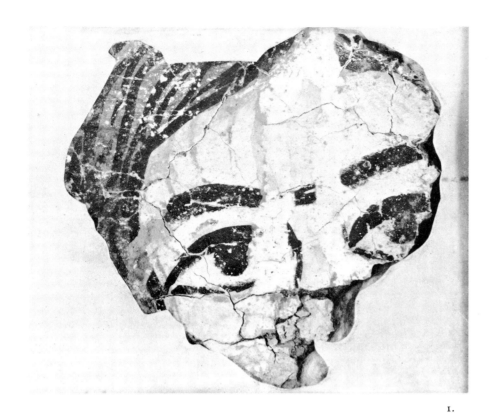

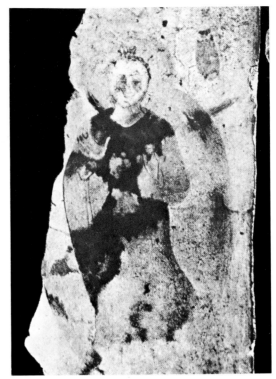

1.

2.

1. Fragment of a Face. Wall Painting
from the Palace of Toprak Kala. Third
or Early Fourth Century. Hermitage,
Leningrad.

2. Abhayamudrā Buddha. Wall Painting.
Probably Fifth Century. Haḍḍa
(Afghanistan).

3. Buddhas and Stylized Stūpas. Wall
Painting. Probably Fifth Century.
Vestibule of the Sanctuary, Group C,
Bāmiyān.

3.

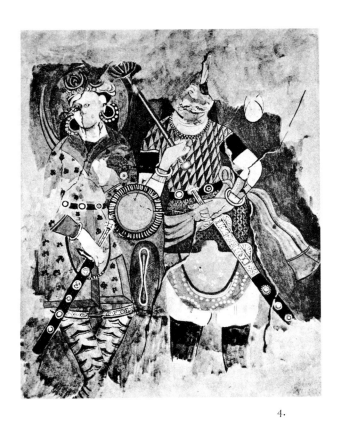

4.

4. Sun and Moon Gods. Wall Painting from Niche K of the Buddhist Monastery of Fondukistān. Probably Seventh Century. Archaeological Museum, Kabul (copy by J. Carl).

5. Dancing Girl and Musicians in a Buddhist Paradise. Wall Painting dated 642. Cave 220, Tun-huang.

6. Bodhisattva and Buddha. Wall Painting. Second Half of the Fifth Century. Cave 272, Tun-huang (copy by Chang Sha-no).

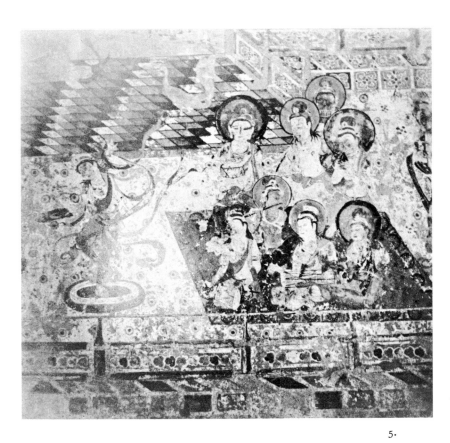

5.

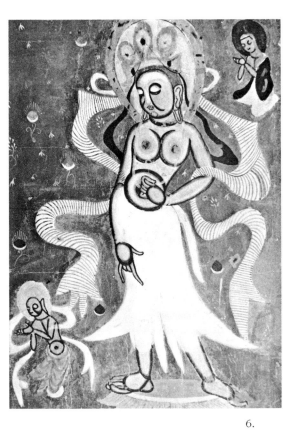

6.

Bibliography

K. Hamada, *Graeco-Indian Influences upon Far-Eastern Art* (in Japanese), Kokka, Nos. 188, pp. 189-197; 189, pp. 232-239; 191, pp. 273-279; 193, pp. 320-326; 196, pp. 350-354, 1906.

A. Grünwedel, *Bericht über archäologische Arbeiten in Idikutschari*, Abhandlungen der Königl. Bayerischen Akademie der Wissenschaften, Munich 1906, XXIV, v, 1.

Sir Aurel Stein, *Ancient Khotan*, Oxford 1907.

A. Grünwedel, *Altbuddhistische Kultstätten in Chinesisch-Turkistan (3. Expedition)*, Berlin 1912.

A. von Le Coq, *Chotscho. Königlich-Preussische Turfan-Expedition (2. Expedition)*, Berlin 1913.

Count Otāni, *Saiiki Kōko Zufu* (Portfolio of plates of Central Asian objects), 1915.

A. Grünwedel, *Altkutscha, archäologische und religionsgeschichtliche Forschungen an Tempera-Gemälden aus buddhistischen Höhlen der ersten acht Jahrhunderte nach Christi Geburt*, Berlin 1920.

Mission P. Pelliot, *Les grottes de Touen-houang*, 6 vols. of plates, Paris 1920-1924.

Sir Aurel Stein, *Serindia*, 5 vols., Oxford 1921.

Sir Aurel Stein, *Ancient Buddhist Paintings from the Cave of the Thousand Buddhas on the Westernmost Frontier of China*, London 1921.

Sir Aurel Stein, *The Thousand Buddhas. Ancient Buddhist Paintings from the Cave-Temples of Tun-huang*, London 1921-1922.

A. von Le Coq and E. Waldschmidt, *Die buddhistische Spätantike in Mittelasien*, 7 vols., Berlin 1922-1933.

R. Grousset, *L'art de l'Asie Centrale et les influences iraniennes*, Revue des Arts Asiatiques, July 1924, pp. 12-16.

E. Matsumoto, *Li-sheng-tien, King of Khotan (938) and the One Thousand Caves at Tun-huang*, Kokka, No. 410, 1924, pp. 14-19.

R. Waldschmidt, *Gandhāra, Kutschā, Turfān. Eine Einführung in die frühmittelalterliche Kunst Zentralasiens*, Leipzig 1925.

A. von Le Coq, *Bilderatlas zur Kunst- und Kulturgeschichte Mittelasiens*, Berlin 1925.

A. von Le Coq, *Auf Hellas Spuren in Ostturkistan. Berichte und Abenteuer der 2. und 3. deutschen Turfan-Expedition*, Leipzig 1926.

A. von Le Coq, *Von Land und Leuten in Ostturkistan. Berichte und Abenteuer der 4. deutschen Turfan-Expedition*, Leipzig 1928.

Sir Aurel Stein, *Innermost Asia*, Oxford 1928.

A. Stein, L. Binyon, *Un dipinto cinese della raccolta Berenson*, Dedalo IX, 5, 1928, pp. 261-282.

A. and Y. Godard, J. Hackin, *Les Antiquités bouddhiques de Bāmiyān*, Mémoires de la Délégation Archéologique Française en Afghanistan, tome II, Paris 1928.

A. Waley, *A Catalogue of Paintings recovered from Tun-huang by Sir Aurel Stein*, Oxford 1931.

E. Matsumoto, *A Characteristic of the Buddhist Paintings in the Khotan District and its Transmission*, Tōyō gakuho, IV, 1931, pp. 227-237 (in Japanese).

J. Hackin and J. Carl, *Nouvelles recherches archéologiques à Bāmiyān*, Mémoires de la Délégation Archéologique Française en Afghanistan, tome III, Paris 1933.

Sir Aurel Stein, *On Ancient Central Asian Tracks*, London 1933.

F. H. Andrews, *Catalogue of Wall-Paintings from Ancient Shrines in Central Asia and Seistan, recovered by Sir Aurel Stein*, Delhi 1933.

F. H. Andrews, *Central-Asian Wall-Paintings*, Indian Art and Letters, vol. VIII, 1934, I.

J. Hackin, *Recherches archéologiques en Asie Centrale (1931)*, Revue des Arts Asiatiques, tome IX, III, 124 (1936); tome X, II, 65 (1938).

J. Hackin, *Buddhist Art in Central Asia. Indian, Iranian and Chinese Influences (from Bāmiyān to Turfān)*, Studies in Chinese Art and some Indian Influences, London 1937.

E. Matsumoto, *Tonko ga no kenkyū* (study of the Tun-huang paintings), 2 vols., Tokyo 1937.

Count Otāni, *Shin Saiiki-ki* (report on the expeditions of 1902), 2 vols., Tokyo 1937.

L. Warner, *Buddhist Wall-Paintings. A Study of a Ninth Century Grotto at Wan fo hsia*, Harvard, Mass. 1938.

B. Rowland, *The Wall-Paintings of India, Central Asia and Ceylon*, Boston, Mass. 1938.

Y. Harada, *The Interchange of Eastern and Western Cultures as Evidenced in the Shōsōin Treasures*, M.R.D.T.B., No. II, Tokyo 1939, pp. 55-78.

J. Auboyer, *Les influences et les réminiscences étrangères au Kondō du Hōryūji*, Paris 1941.

S. Taki, *Daijō Bukkyō no Shinbi-kan* (Conception of the aesthetics of Mahāyāna Buddhism), Kokka, September 1943, No. 634, 261-265; October 1943, No. 635, pp. 287-290.

F. H. Andrews, *Wall-Paintings from Ancient Shrines in Central Asia recovered by Sir Aurel Stein*, Oxford University Press, London 1948.

S. P. Tolstov, *Po sledam drevnechorezmijskoj civilizacii*, Moscow-Leningrad 1948.

S. P. Tolstov, *Drevnij Chorezm*, Moscow 1948.

A. C. Soper, *Aspects of Light Symbolism in Gandhāran Sculpture*, Artibus Asiae, 1949, vol. XII, 3, pp. 252-283; XII, 4, pp. 314-330; 1950, XIII, 1-2, pp. 63-85.

R. Grousset, *La Chine et son art*, Paris 1951.

Živopis drevnego Pjandžikenta (A. Ju. Iakubovskij, A. M. Belenickij, M.M. D'jakonov, P.I. Kostrov), Akademii Nauk SSSR, Moscow 1954.

M. Bussagli, *L'influsso classico ed iranico sull'arte dell'Asia centrale*, Rivista dell'Istituto Nazionale d'Archeologia e Storia dell'Arte, Rome, new series II, 1953 (1954), pp. 171-262.

W. R. B. Acker, *Some T'ang and pre-T'ang Texts on Chinese Painting*, Leyden 1954.

Tun-huang pi hua chi ch'ung lu (A Portfolio of hand copies after the Tun-huang Wall-Paintings prepared by the Tun-huang Institute), Peking 1955.

Hsieh chih-liu, *Tun huang yi-shu hsü-lu* (Descriptive Catalogue of the Art of Tun-huang), Shanghai 1955 (in particular Ch'ien-fo tung).

O. Sirèn, *Central Asian Influences in Chinese Painting of the T'ang Period*, Arts Asiatiques, III, 1956, pp. 3-21.

Sculptures et peintures de l'Asie Centrale. Inédits de la Mission Paul Pelliot, Paris 1956. Text by L. Hambis and M. Hallade with the collaboration of Mlle Lotiron (catalogue of the exhibition held at the Musée Guimet, Paris, winter 1956).

L. Hambis, *Sculptures et peintures de Haute Asie. Inédits de la collection Pelliot*, La Revue des Arts, VI, 1956, pp. 3-8.

O. Sirèn, *Chinese Painting*, vol. I, London 1956-1958.

Siri Gunasinghe, *La Technique de la Peinture Indienne d'après les textes du Śilpa*, Paris 1957.

Nobuo Kumagai, *A Painted Casket from Kucha, East Turkistan* (in Japanese), Bijutsu Kenkyu, No. 191, March 1957, pp. 239-265.

Nobuo Kumagai, *Central Asian Painting*, Heibonsha, Tokyo n.d.

Turfān and Gandhāra. Frühmittelalterliche Kunst Zentralasiens, Berlin 1957. Text by Herbert Härtel (catalogue of the exhibition held in Berlin in October 1957).

O. Maenchen-Helfen, *Crenelated Mane and Scabbard Slide*, Central Asiatic Journal, III, 1957, pp. 85-138.

T. Akiyama, *The Three Wooden Caskets from Subashi in the Kucha Region, brought back by the Pelliot Mission*, Bijutsu Kenkyu, No. 191, March 1957, pp. 266-286.

G. Scaglia, *Central Asians on a Northern Ch'i Gate Shrine*, Artibus Asiae, vol. XXI, 1, 1958, pp. 9-28.

Huang wen-pi, *T'a-li-mu-p'en-ti k'ao-ku chi* (archaeological report on the Tarīm basin). Chung-kuo t'ien yeh k'ao-ku pao-kao chi (report on Chinese excavations). Chung-kuo k'o-hsüeh yüan, Chinese Academy, Peking 1958.

L. Hambis, *Asia Centrale*, Enciclopedia Universale dell'Arte, vol. II, col. 1-25, Rome-Venice 1958.

M. Bussagli, *L'arte del Gandhāra in Pakistan e i suoi incontri con l'arte dell'Asia Centrale* (catalogue of the exhibition held in Rome and Turin in 1958), Rome 1958.

A. M. Belenickij, *Obšie rezul'tatj raskopok gorodiša drevnego Pendžikenta (1951-1953)*, Materialj i issledovanija po Archeologii SSSR, No. 66. Trudj Tadžiskoi archeologičeskoi ekspedicii Tom. III, Akademii Nauk SSSR, Moscow-Leningrad 1958, pp. 104-154.

A. M. Belenickij, *Nouvelles découvertes de sculptures et de peintures murales à Piandjikent*, Arts Asiatiques, V, 3, 1958, pp. 163-182.

O. G. Bol'šakov and N. N. Negmatov, *Raskopki v prigorode drevnego Pendžikenta*, Materialj i issledovanija po Archeologii SSSR, No. 66. Trudj Tadžiskoi archeologičeskoi ekspedicii Tom. III, Akademii Nauk SSSR, Moscow-Leningrad 1958, pp. 155-192.

B. L. Voronina, *Architektura drevnego Pendžikenta (Itogi robot 1952-1953)*, ibidem, Akademii Nauk SSSR, Moscow-Leningrad 1958, pp. 193-215.

S. P. Tolstov, *Les résultats des travaux de l'expédition archéologique et ethnographique au Kharezm de l'Académie des Sciences de l'URSS en 1951-1955*, Orientalia Romana, I, Rome 1958, pp. 119-168 (see also Arts Asiatiques, IV, 1957, pp. 84-112 and 187-198).

A. C. Soper, *Northern Liang and Northern Wei in Kansu*, Artibus Asiae, vol. XXI, 2, 1958, pp. 131-164.

A. C. Soper, *T'ang Ch'ao Ming Hua Lu. Celebrated Painters of the T'ang Dynasty, by Chu Ching-hsüan of T'ang*, Artibus Asiae, vol. XXI, 3-4, 1958, pp. 204-230.

A. C. Soper, *Literary Evidence for Early Buddhist Art in China*, Artibus Asiae, Suppl. XIX, 1959.

J. Hackin, J. Carl and J. Meunié, *Diverses recherches archéologiques en Afghanistan (1933-1940)*, Mémoires de la Délégation Archéologique Française en Afghanistan, tome VIII, Paris 1959.

B. Gray, *Buddhist Cave Paintings at Tun-huang*, Faber & Faber, London 1959.

A. M. Belenickij, B. Ja. Staviskij, *Novoe o drevnem Pendžikente*, Archeologi rasskazyvajut, Stalinabad 1959, pp. 38-65.

Skulptura i Zivopis' drevnego Pjandžikenta (A. M. Belenickij, B. L. Voronina, P. I. Kostrov), Akademii Nauk SSSR, 1959.

H. Härtel, *Indische und zentralasiatische Wandmalerei*, Berlin 1959.

L. I. Al'baum, *Balalik Tepe*, Akademija Nauk Uzbeskoi SSR, Institut Istorii Archeologii, Tashkent 1960.

N. Diakonova, *A Document of Khotanese Buddhist Iconography*, Artibus Asiae, vol. XXIII, 3-4, 1960, pp. 229-230.

D. Schlumberger, *Descendants non-méditerranéens de l'art grec*, Syria, 1960, pp. 131-166 and 253-318.

K. Yamasaki, *Pigments in the Wall-Paintings in Central Asia*, Bijutsu Kenkyu, No. 212, Sept. 1960, pp. 135-137.

T. Akiyama, *The Painted Dado of Cella M. V at Mirān Site*, Bijutsu Kenkyu, No. 212, Sept. 1960, pp. 138-143.

L. Hambis (editor), *Toumchouq, I*, Mission Paul Pelliot, Paris 1961.

B. Rowland Jr., *The Bejewelled Buddha in Afghanistan*, Artibus Asiae, vol. XXIV, 1961, pp. 20-24.

N. Kumagai, *Paintings of Praṇidhi Scenes in the Otāni Collection*, Bijutsu Kenkyu, No. 218, Sept. 1961, pp. 1-26.

S. Hirano, *A Study of the Praṇidhi Scene according to the Inscriptions of the Cave Temple No. 9 Bäzäklik*, Bijutsu Kenkyu, No. 218, September 1961, pp. 27-44.

F. Fourcade, *La peinture murale de Touen-Houang*, Editions Cercle d'Art, Paris 1962.

B. Rowland, *Religious Art. East and West*, History of Religions, vol. 2, No. 1, Summer 1962, pp. 11-32.

L. Hambis, *Kučā centri*, Enciclopedia Universale dell'Arte, vol. VIII, col. 498-506, Rome-Venice 1963.

L. Hambis, *Khotanesi centri*, Enciclopedia Universale dell'Arte, vol. VIII, col. 472-480, Rome-Venice 1963.

General Index

Abbasid period 121.
Abhayamudrā Buddha 124.
Afghanistan 14, 17, 20.
Afrigid dynasty (Chorasmia) 20, 36.
afšin (prince, in Sogdian) 43.
Agni, or Qarāšāhr 14, 69.
Airtam Termez, ancient Tarmita (Bactria) 35.
Ajaṇṭā (India), wall paintings 42, 61, 78.
Al'baum L.I. 35.
Altaic tribes 14.
Altin-tāgh mountains 14.
Amitābha-Amitāyus, supreme Buddha 34, 35.
Amu Darya (Oxus) 12.
Ani (Armenia) 45.
Aqsu (Chinese Ku-mo) 14, 15, 69.
Arab conquest of Central Asia 11, 12, 19, 43, 47.
Arabs 101, 121.
Armenia, Christian churches 45.
Asia Minor, commerce with 14.
Astāna (Turfān area) 116, 118.
Avalokiteśvara, Bodhisattva 119, 120.
Avlod, legendary knight 45, 47.

Bactra 36.
Bactria 40.
Balalik Tepe, near Airtam Termez (Bactria) 35, 36, 40, 43, 61, 63.
Balawaste (Domoko area) 52, 55, 58, 60, 61.
Bāmiyān, caravan town and religious centre 36, 53, 70;
paintings 38/40, 48, 56, 58, 61, 124;
colossal statues of the Buddha 36, 37, 40.
Bäzäklik, near Turfān 96, 101, 104;
wall paintings 98/100, 102, 103, 106, 107, 109, 110, 112, 119, 121.
Begrām (Kāpiśī), Afghanistan, ivories 86.
Belenickij A.M. 47.
Berenson Scroll (Settignano, near Florence) 64, 65, 67, 116.
Berlin, Staatliche Museen, Indische Kunstabteilung:
relief from Gandhāra 21, 23;
wall paintings detached from:
Bäzäklik 102, 103, 106, 107, 109;
Dāndān Öilüq 62;

Qïzïl 30, 49, 68, 72/77, 79/82, 84, 85;
Qočo (wall paintings, embroidery, painted banners, manuscripts) 3, 4, 26, 33, 50, 97, 105, 108, 112, 113;
Qumtura 88, 89, 91;
Sängim Gorge (Turfān area) 34;
Šōrčuq 93;
Tumšuq 70.
Bhārhūt, ancient art centre (India) 24.
Black Sea 11, 14.
Bodhisattva 33, 48, 50, 57, 58, 61, 63, 83, 84, 90, 91, 117, 119, 120, 125.
Boston, Museum of Fine Arts 67.
Brahmanism, religion of India 32.
Brussels, Stoclet Collection 67.
Buddha, episodes from the life of 26, 28, 32, 35, 90, 94, 101, 110;
representations of 21, 23, 26, 27, 32, 34, 36/40, 55, 58, 61, 62, 69, 70, 88, 90, 92, 94, 96, 97, 98, 101, 104, 110, 117, 119, 124.
Buddhism 13, 15, 20, 28, 31, 32, 35, 36, 39, 42, 47, 53, 58, 61, 63, 83, 94, 95, 101, 115, 116, 121, 125;
Tantric Buddhism 32, 58, 60, 61, 63, 90, 96, 104;
Buddhist art 14, 17, 21, 28, 32, 42, 66, 96, 101, 104, 111, 112, 121, 125.
Byzantine art and its influence 11, 17, 21, 35, 36, 44, 73, 83, 111, 119, 122.

Candraprabha, legendary Queen 48, 49.
Caravan routes 11/15, 20, 23, 36, 58, 69, 93, 95.
Caspian Sea 11.
Čerčen (Chinese Shan-shan) 14.
Chang Yen-yüan, Chinese art historian (9th century) 53.
Ch'ang-an, ancient capital of China 43, 66;
Fêng-ên ssu, temple 66.
Ch'en Yung-chih, Chinese painter: copy of a *Šākyamuni* by I-seng (Boston) 67.
Ch'i (Northern) dynasty of China (550-577 A.D.) 53.
Ch'in (Early) dynasty of China (351-394 A.D.) 31.
China and its political influence 11/15, 20, 31, 35, 43, 44, 58, 66, 67, 69, 83, 95, 96, 101, 115, 119.

Chinese art and its influence 15, 20, 28, 31, 53, 63, 66, 67, 71, 83, 89, 90, 93, 96, 101, 104, 111, 116, 119; influence of Khotanese painting 17, 66, 67, 121; coins 43;
texts, records, poetry, literature 12, 21, 35, 39, 53, 66, 67, 95, 115, 121.
Ching-chüeh, Chinese name of Niya 14.
Ch'iu-tzu, Chinese name of Kučā 14.
Chorasmia and the influence of its art 14, 15, 20, 28, 29, 36, 53, 66.
Christian art, influence of 45.
Chü-mi, Chinese name of Keriya 14.
Classical inspiration in art of Central Asia 11, 14, 15, 17, 20, 21, 27/29, 36, 42, 75, 78, 96, 101, 104.

Damascus mosaics 21.
Dāndān Öilüq (Khotan area), wall paintings 62, 63, 66, 67, 111;
wooden votive tablets 56, 57, 59, 61, 63.
dev, half-animal demons 44, 47.
deva, divinities of India 31, 99, 101.
Dharma, Good Law of the Buddha 13, 35, 94.
Dhṛtarāṣṭra, Guardian of the East 116, 119.
Diakonov M. 44, 47.
Diakonova Natalia 61.
Dīpaṃkara, one of the Buddhas of the Past 32.
Domoko (east of Khotan), wall paintings and monuments 56, 58, 61, 63.
Duḥtar-i-Nuširwān (Afghanistan) 36.

Endere (Turkestan) 21.
Ereruk (Armenia) 45.
Eurasia 13, 19.
Europe, commerce with 11, 15; medieval art and culture 16, 17, 28, 35, 122.
Expeditions to Central Asia 20, 47, 69.

Farhād Bēg-yailaki, wall paintings 54, 58.
Fatimid period 121.
Fêng-ên ssu, temple at Ch'ang-an 66.
Ferghāna, province 14, 36.
Firdūsi, Persian poet (933-1021/25), *Shāh-nameh* 47.

Fondukistān, Buddhist monastery 40, 41, 48, 125.
Fu Chien, ruler of the Early Ch'in dynasty (351-394) 31.

Gandhāra 20, 28, 83;
school of art and its influence 20, 21, 23, 28, 32, 36, 40, 42, 58, 61, 67, 75, 83, 86, 87, 90, 104;
sculpture, carvings 21, 23, 25, 27, 32, 36.
Ghaznavid art 121.
Ghaznī (Afghanistan), coins 39.
Golubev 119.
Greece, influence of 12, 15;
Greco-Roman art 20, 121.
Grousset René 69, 96.
Gupta art and empire 15, 36, 40, 42, 53, 56, 119.
Gyantse (Tibet) 67.

Haḍḍā (Afghanistan) 36, 124.
haft khwān (The Seven Tales) from the Shāh-nameh 47.
Hamelin P. 86.
Ha-mi, Chinese name of Qōmul 14.
Han dynasty of China (Early Han, 206 B.C.-23 A.D. and Later Han, 23-220 A.D.) 20, 21, 58, 95.
Hāritī, protectress of childhood (converted female demon) 54, 58.
Harwan (Kashmir), temple of 87.
Hellenism, Hellenistic influence 14, 20, 21, 24, 122.
Hephthalites, nomads 35.
Hīnāyāna, Buddhist doctrine 35, 36, 58, 70, 90.
Hinduism, religion of India 42.
Hoti Mardan, collection of the Corps of Guides 23, 86.
Hsiung-nu, nomads 16.
Hsüan-tsang, Chinese Buddhist pilgrim 66.
Huns 16.
Hvarənāh, Splendour and Power of divine and human sovereigns 32.

Idiqutšahri, city of the Idiqut (Turfān) 95.
I-hsin or I-hsün, Han colony 21.
Ilkhanid art 111.
India 11, 13/15, 20, 32, 42, 71, 115;
art and its influence 17, 28, 32, 36, 40, 42, 47, 53, 56, 58, 61, 63, 66, 69, 71, 73, 78, 83, 90, 96, 104, 116, 119, 121;
religious influence 12/14, 28, 29, 111, 119;
Gupta period 15, 36, 40, 42, 53, 56, 119.
Indo-European stocks 11, 14, 16, 95.
Indo-Greek culture 15.
Indo-Iranian influence 17, 28, 35, 48, 53, 70, 71.
Indo-Scythian influence 15, 61, 63, 67.
Iran 11/15, 20, 43, 71, 111, 115;
religious influence 12, 13, 15, 28, 35, 36;
art and its influence 20, 21, 27, 28, 35, 36, 40, 42/44, 47, 57, 58, 69, 71, 73, 78, 83, 86, 87, 89, 90, 96, 101, 104, 111, 116, 119, 121;
influence of "outer Iran" 14, 15, 35, 40, 43, 47, 53, 69;

Islamic Iran 15, 46, 96;
Parthian Iran 15, 27, 48;
Sassanian Iran 15, 21, 35, 36, 40, 43, 47, 53, 58.
I-seng, see Wei ch'ih I-seng.
Islam, penetration of 15, 16, 19, 43, 69, 95, 96, 122;
art, miniatures 15, 46, 51, 78, 111, 121.
I wang (Tibet), temple paintings in the Khotanese manner 67.

Japan 115, 119; Japanese expeditions 69.
Jātaka scenes 21, 47, 78.
Jaxartes (Syr Darya) 14.
Juan-juan, nomads 35.

Kabul, Archaeological Museum:
paintings from Bāmiyān 38; from Fondukistan 41, 125; from Kakrak 39.
Kakrak, near Bāmiyān 53, 58, 61;
wall paintings 39, 40, 56.
Kanishka, Kushan king (128?-141? A.D.) 58.
Kansu province (China) 12, 31, 115.
Kao-ch'ang, Chinese name of Turfān 14, 95, 96.
Kašgar (Chinese Su-lē) 13, 14.
Kashgaria 14, 115.
Kashmir 17, 87.
Keriya (Chinese Chü-mi) 14.
kēyurā, Indian bracelets 40.
Kharoṣṭhi inscriptions 21.
Khorasan region 43.
Khotan 14, 15, 53, 56, 58, 59, 61, 63, 66, 119, 122;
school of painting 53, 66, 111, 116;
its influence 53, 66, 67, 93, 121;
Khotanese language 16, 58.
Kidarites, nomads 35.
Kirghizia 43.
Kiselev S. 16.
K'iu, Chinese dynasty at Turfān 95.
Korean religious influence 13.
K'o-tzu-erh ming-wu (west of Kučā) 69, 70, 90.
K'ri gtsung lde btsan Ral pa can (815-838 A.D.), king of Tibet 67.
kṣayabhāga and vṛddhibhāga, "increase" and "decrease" in Indian painting 32.
Kṣitigarbha, Bodhisattva 116, 117, 119.
Kučā (in Chinese Ch'iu-tzu), caravan city 14/16, 31, 58, 61, 69/71, 75, 78, 83, 86, 89, 90, 93, 94, 96, 104, 119, 121, 122; Iranian exiles 43, 69; school of painting and its influence 28, 47, 48, 56, 69, 78, 96; style "without development" 16, 48; wooden tablets, reliquaries, etc. 71, 83, 86, 87.
Kufic characters 121.
Ku-mo (Chinese name of Aqsu) 14.
Kumārajīva, Buddhist commentator in China (c. 383) 31.
kumbum of the great temple of Gyantse (Tibet) 67.
Kuo Jo-hsü, 11th-century Chinese critic 53.
Kushan empire 20, 21, 32, 48, 58, 61;

Kushano-Afrigid paintings of Chorasmia 20, 36;
Kushano-Iranian influence 21.
kustī, long floating ribbons 35, 61.

Laškari Bazar, palace of 121.
Leningrad, Hermitage: wall paintings from Pjandžikent 44/46, 112; from the palace of Toprak Kala 124.
li lugs, paintings "in the Khotanese manner" (Tibet) 67.
Liang (Later), dynasty of China (386-405 A.D.) 31.
lingua franca of Sogdiana 16, 51.
Lokāpala, guardian of the four cardinal points 67, 116, 119.
Lokottaravadin, Buddhist sect 70.
London, British Museum:
wooden tablets from Dāndān Öiliq 56, 57, 59.
Lou-lan (Chinese Turkestan) 21.
Lü Kuang, General under Fu Chien (late 4th century) 31.
Lung-men (China), gigantic sculptures 53.

Mahākaśyapa, ascetic 71, 73, 75.
Mahāyāna, Buddhist doctrine 35, 58, 90, 96.
Maitreya, Bodhisattva 40, 41.
Mani (215/16-277) 36, 43.
Manichaeism 13, 43, 47, 95, 96, 111;
Manichaean manuscripts 3, 4, 46, 51, 111.
Mathūra (India) 42, 78.
Medici Venus 66.
Mediterranean world 11, 13, 20.
ming-ch'i, funerary figurines 101.
Ming-oï (Thousand Caves), near Šōrčuq 92.
Mingora (valley of the Swat) 71.
Mirān 14, 19, 71;
wall paintings 18, 20/25, 27/29, 31, 86.
mithunā (couple) 28.
Mongolia 12;
Mongol features in figure paintings 63, 90, 92, 111.
Moslem works 95, 121.
Murtuq 96, 112.

Nāginī, deity 66.
Napkī, type of coins of Ghaznī 39.
Nestorian Christianity 13, 45, 95, 96, 111/114.
New Delhi, collection of the National Museum, wall paintings detached from:
Balawaste 52, 55, 60;
Bäzäklik 98/100, 110;
Farhād Bēg-yailaki 54;
Mirān 18, 22/25;
Šōrčuq (from Ming-Oï) 92.
Niya (Chinese Ching-chüeh) 14, 21.

Oxus (Amu Darya) 12, 14.

padmāsana, seated position of the Buddha 36.
Palermo, Palatine Chapel 121.
Palmyra, influence of the art of 27.
Pamirs 13.
Pan ch'ao, Chinese Han general 58.

130

Paris, Musée Guimet:
 scroll paintings from Tun-huang 117, 120; from Astāna 118.
Parthian art, influence of 15, 48.
Pelliot, Paul 21.
Persepolis, sculpture and architecture of 21.
Peshawar Museum 86.
Pjandžikent (Sogdiana) 32, 40, 43, 44, 111, 121;
 wall paintings 15, 43/48, 53, 83; statuettes 48.
Po-chih-na, see Wei ch'ih Po-chih-na.
pradakṣiṇā, Buddhist rite 24.

Qara Khōja 116.
Qarāšāhr, or Agni (Chinese Yen-ch'ih) 14, 15, 69, 93, 94, 96.
Qïzïl, near Kuča 31, 61, 69, 70, 89, 90, 104;
 wall paintings 61, 76; style "without development" 16, 48;
 Cave of the Coffered Ceiling 30, 31;
 Cave of the Frieze of Musicians 84;
 Cave of the Navigator 68, 71, 73, 74, 78;
 Cave of the Niches 77;
 Cave of the Painted Floor 81;
 Cave of the Statues 72;
 Cave of the Sword Bearers 80;
 Cave of the Temptations 82;
 Large Cave 71, 75;
 Peacock Cave 79;
 Third Earlier Cave 85;
 Treasure Cave 40, 48, 49.
Qočo, wall paintings 26, 33, 95/97; from the Nestorian Temple 111/113; paintings on embroidery, scrolls, banners, etc. 3, 4, 48, 105, 108.
Qōmul (Chinese Ha-mi) 14.
Qumtura, near Kuča, wall paintings 28, 69, 71, 89/91, 96;
 Cave of the Apsaras 89;
 Cave with a Low Entrance 88.

Ravenna mosaics, influence of the 111, 119.
rGyal rab, Tibetan records 67.
Roman empire 13, 15;
 art 27, 122.
Romano-Sarmatian schools of South Russia 20.
Rūpāvatī, Bodhisattva 83, 84.
Russia 20; researches by Soviet archaeologists 20, 47.
Rustam, Iranian hero 44, 45, 47.

Saddharmapuṇḍarika-Sūtra, Buddhist work 35.
Sahri Bahlol, religious centre of Gandhāra 86.
Sakas, tribe 16;
 Saka Khotanese language 16, 58.
Śākyamuni, Buddha 32, 35, 67.
Samarra (Iran) 121.
Saṃgha, community of Buddhism 94.
Sängim Gorge, near Turfān 34, 96.
Sarmatians, tribe 14, 16;
 Romano-Sarmatian schools of South Russia 20.
Sassanian empire (226-642 A.D.) 21, 35, 36, 43, 69, 78;

art and its influence 15, 16, 36, 40, 43, 47, 53, 58, 61, 63, 66, 71, 90, 93, 104;
 Sassano-Gupta influence 40; sculpture 47.
Saveh, ceramics (12th century) 111.
Schlumberger, Daniel 121.
Scythians 14/16.
Seljūk art 121.
Serindia (Sinkiang) 31, 35, 36.
Settignano, near Florence, Berenson Collection 64, 65.
Shāh-nameh 47.
Shamanism, influence of 87.
Shan-shan, Chinese name of Čerčen 14.
Silk Road 14, 15, 20, 23.
Śilpa-Śastra, Indian technical handbooks 29, 32.
Śilpin, Indian works 63.
Sinkiang province (China) 11, 15.
Siren, Osvald 67.
Śivaite religion of India 61, 63.
So-chü, Chinese name of Yarkand 14.
Sogdiana, province on the Silk Road 14, 15, 36, 40, 43, 45, 46, 83, 111, 122;
 art and its influence 40, 48, 51, 53, 61, 66;
 Sogdian literature, language 16.
Soper, A.C. 31.
Šōrčuq 92/94, 96, 101.
Śravastī, great miracle of 32.
Stein, Sir Aurel 21, 27.
Su-lē, Chinese name of Kašgar 14.
Sui dynasty of China (589-617) 31, 35, 66, 71.
Sukhāvativyūha, Indian literary work 35.
Sung dynasty of China (960-1279 A.D.) 90.
Sung Yün, Buddhist pilgrim (c. 519) 61.
Suvarnaprabhāsa, Buddhist work 35.
Swat Valley 23, 71.
Syr Darya (Jaxartes) 14.
Syria, commerce with 16;
 influence of the art of 36, 96, 111.

Tadžikistan (Soviet republic) 11, 43.
Taki S. 35.
Taklamakan Desert 13.
T'ang dynasty of China (618-906) 15, 35, 43, 53, 63, 66, 90, 95, 101;
 realism of T'ang art 28, 94, 96.
t'anka (Tibetan), banner 67.
Tarīm basin 12, 20, 69.
Tārišlark (Khotan), wall paintings of the temple 61, 67.
Taxila 36.
Tibet, influence of 12, 21, 67, 95;
 influence of Central Asia on the art of Tibet 17, 53, 67, 121.
Tita, painter of Mirān 21, 23.
Tokyo, National Museum 82;
 Terizo Kimura Collection 83, 86, 87.
T'o-pa Wei, nomad dynasty 35.
Toprak Kala (Russia), palace of 124.
Toyuq, in the Turfān area 96, 121.
Transcaucasian art 44.
Ts'ao Chung-ta, Sogdian painter (6th century) 53.
T'u-chüeh, Turkish empire (6th century) 35, 95.
Tumšuq 15, 69, 70, 75.

Tun-huang (Kansu province) 13, 94, 115, 119;
 wall paintings 20, 28, 31, 32, 35, 43, 67, 71, 78, 104, 115, 119, 125; scrolls, banners, etc. 115/117, 120.
Turfān (Chinese Kao-ch'ang) 14, 34, 63, 90, 94, 95, 104, 111, 114/116, 121, 122;
 works from the Uighur period 28, 32, 111; wall paintings 96, 119; scrolls 16.
Turkestan, Russian 11, 14.
Turkish peoples 16, 46; infiltrations of 11, 16, 95;
 Turkish painting 15, 87, 96, 101, 104;
 Turco-Iranian elements 47, 111, 119, 121.
Turkmenistan (Soviet Republic) 11.
Tuṣita Heaven 89, 90.

Uč Turfān (Chinese Wen-su) 14.
Uighur, Turkish empire of the 90, 95, 96, 101, 105/107, 114, 121;
 scrolls, miniatures, ex-voto paintings 101, 104, 105, 108, 111, 116.
Urals 11, 114.
uṣnisa, headgear of the Buddha 23.
Uzbekistan (Soviet Republic) 11.

Vaiśravaṇa, Lokapāla 67.
vajra, thunderbolt 61, 63.
Vajrapāṇi, Bodhisattva 21, 23, 70.
Vajrayāna, Buddhist doctrine 35.
Valahassa Jātaka 78.
Varakhša, town 43.
Vedic religion of India 32.
Vehicle, Great and Little 70.
Villages with "inhabited walls" 14.
Villard de Honnecourt (active c. 1230-1235) 58.
Viśvantara Jātaka 21, 27.
Vṛddhibhāga and *Kṣayabhāga*, "decrease" and "increase" in the technique of Indian painting 32.

Wei (Northern), dynasty of China (6th century) 31, 35, 71, 83.
Wei ch'ih Chia-seng, Khotanese painter (7th century) 66.
Wei ch'ih I-seng, or Wei ch'ih the Younger 64/67, 116;
 copies of his works: Boston; Brussels, Stoclet Collection; Berenson Collection 67.
Wei ch'ih Po-chih-na, or Wei ch'ih the Elder, painter from Khotan (active at Ch'ang-an, 589-617) 66.
Wen-su, Chinese name of Uč Turfān 14.
Wu-sun, Sarmatian tribe 16.
Wu Tao-tzu, Chinese painter (T'ang period, 7th century) 67.

Yarkand (Chinese So-chü) 14, 58.
Yen-ch'i, Chinese name of Qarāšāhr 14.
Yen Li-pen, Chinese painter (7th century) 66.
Yotkān (Chinese Yü-t'ien) 58.
Ysufzai, north-east of Gandhāra 23.
Yü-ni (China) 21.
Yun-kang (China), sculptures 53.

List of Illustrations

THIRD CENTURY

Heads of Two Worshippers. Wall Painting from Mirān. Second Half of the Third Century A.D. (Width 8″)
M. III 0019, Collection of the National Museum, New Delhi 18

Unidentified Religious Scene. Wall Painting from Mirān. Second Half of the Third Century A.D.
(Height c. 29″) M. III 002, Collection of the National Museum, New Delhi 22

The Buddha attended by Six Monks. Wall Painting from Mirān. Second Half of the Third Century A.D.
(Width 39½″) M. III 003, Collection of the National Museum, New Delhi 23

Fresco with Garlands and Figures, details. From Shrine V, Mirān. Second Half of the Third Century A.D.
(Height c. 17½″) Collection of the National Museum, New Delhi 24, 25

Fragment of a Face. Wall Painting from the Palace of Toprak Kala. Third or Early Fourth Century.
Hermitage, Leningrad . 124

FOURTH CENTURY

Colossal Statue of the Buddha at Bāmiyān. Fourth-Fifth Centuries. (Height 175 feet) 37

FIFTH CENTURY

Abhayamudrā Buddha. Wall Painting. Probably Fifth Century. Haḍḍa (Afghanistan) 124

Buddhas and Stylized Stūpas. Wall Painting. Probably Fifth Century. Vestibule of the Sanctuary,
Group C, Bāmiyān . 124

Bodhisattva and Buddha. Wall Painting. Second Half of the Fifth Century. Cave 272, Tun-huang (copy
by Chang Sha-no) . 125

Maṇḍala with the Buddha Preaching, surrounded by Smaller Buddha Figures. Ceiling Painting in a
Dome, from Bāmiyān. Fifth-Sixth Centuries. (Diameter 33⅞″) Archaeological Museum, Kabul 38

The "Hunter King" with Two Buddhas seated on Lotus Flowers. Wall Painting from the Drum of a
Dome at Kakrak. Fifth-Sixth Centuries. (Length 51½″) Archaeological Museum, Kabul . . . 39

SIXTH CENTURY

The Dance of Queen Candraprabha. Wall Painting from the Treasure Cave, Qïzïl. About 500. (Height 63″)
I B 8443, Indische Kunstabteilung, Staatliche Museen, Berlin 49

Cowherd. Wall Painting from the Cave of the Statues, Qïzïl. About 500. (Width 10¾″) I B 8838, Indische
Kunstabteilung, Staatliche Museen, Berlin 72

Figures armed with Swords. Wall Painting from the Peacock Cave, Qïzïl. About 500. (c. 22×17″)
I B 8842, Indische Kunstabteilung, Staatliche Museen, Berlin 79

Wall Paintings from the Cave of the Navigator, Qïzïl. About 500. Indische Kunstabteilung, Staatliche Museen, Berlin:

— Monk in Meditation before a Skull. (Width 14¼″) I B 8401 68

— Swimmers. (Width 13½″) I B 8398 73

— Young Ascetic. (Width 13¾″) I B 8389 74

Hāritī with Five Children. Wall Painting from Shrine XII, Farhād Bēg-yailaki. Mid-Sixth Century. (Width c. 18½″) 20 F. XII 004, Collection of the National Museum, New Delhi 54

Buddha in Meditation. Wall Painting, probably from Balawaste. Mid-Sixth Century. (Height c. 31½″) Har. D., Collection of the National Museum, New Delhi, Gift of L. Harding 55

The Buddha, Vajrapāṇi and a Bearded Figure. Wall Painting from the Eastern Zone of Tumšuq. Sixth Century (?). (Height 19¼″) I B 8716, Indische Kunstabteilung, Staatliche Museen, Berlin . . 70

SEVENTH CENTURY

Worshipper. Wall Painting, probably from Balawaste. Early Seventh Century. (Height 21″) Collection of the National Museum, New Delhi 52

Kneeling Monk. Wall Painting from the Temple above the Cave of the Niches, Qïzïl. About 600 (?). (30½×11″) I B 8487b, Indische Kunstabteilung, Staatliche Museen, Berlin 77

Head of the Ascetic Mahākaśyapa. Wall Painting from the Large Cave, Qïzïl. 600-650. (Height 15¾″) I B 8373a, Indische Kunstabteilung, Staatliche Museen, Berlin 75

Monks and Ascetics (above) with Donors (below). Wall Painting from Qïzïl. 600-650. (Height 21⅞″) I B 8372b, Indische Kunstabteilung, Staatliche Museen, Berlin 76

Donors. Wall Painting from the Cave of the Sixteen Sword Bearers, Qïzïl. 600-650. (Height 63″) I B 8691, Indische Kunstabteilung, Staatliche Museen, Berlin 80

Goddess and Celestial Musician. Wall Painting from the Cave of the Painted Floor, Qïzïl. 600-650. (Width 53″) I B 8420b, Indische Kunstabteilung, Staatliche Museen, Berlin 81

Scene of Worship. Wall Painting from the Cave of the Temptations (?), Qïzïl. 600-650. National Museum, Tokyo . 82

Avadāna of Rūpāvatī: The Sacrifice of the Bodhisattva (?). Wall Painting from the Cave of the Frieze of Musicians, Qïzïl. 600-650. (12×10¼″) I B 8390, Indische Kunstabteilung, Staatliche Museen, Berlin . 84

Dancing Girl and Musicians in a Buddhist Paradise. Wall Painting dated 642. Cave 220, Tun-huang 125

Worshipper (God or King). Wall Painting from the Cave of the Coffered Ceiling, Qïzïl. About 650. (23¾×13⅞″) I B 8900, Indische Kunstabteilung, Staatliche Museen, Berlin 30

Buddha and Praying Monk. Wall Painting from the Cave with a Low Entrance, Qumtura. About 650. (18×16″) I B 9024, Indische Kunstabteilung, Staatliche Museen, Berlin 88

Young Brahman. Wall Painting from the Third Earlier Cave, Qïzïl. 650-700. (31¾×11¼″) I B 9030, Indische Kunstabteilung, Staatliche Museen, Berlin 85

Wall Paintings from Pjandžikent. Seventh Century. Hermitage, Leningrad:

— Rustam leading his Warriors against the Dev. Room 41, Sector VI 44

— Rustam lassoing Avlod. On the right, Dragon spitting Flames from its Wounds. Room 41, Sector VI 45

— Two Men playing a Game . 46

The Berenson Scroll, details: Dancer and Dancing Girl. Copy made before 1032 of a Seventh Century Painting by Wei ch'ih-I-seng. By Courtesy of the President and Fellows of Harvard College. Villa I Tatti, Settignano, near Florence 64, 65

Kuča Reliquary. Probably Seventh Century. Terizo Kimura Collection, Tokyo:
— Detail of the lid: Medallion with Music-making Cupid 86
— Detail of a side panel: Masked Dancers 87

Buddha in Meditation. Wall Painting from Dāndān Öilüq (Khotan). Probably Seventh Century.
(Height 7″) I B 9273c, Indische Kunstabteilung, Staatliche Museen, Berlin 62

Blue Lotus Maitreya. Wall Painting from Niche E of the Monastery of Fondukistān. Seventh Century.
(Width 9½″) Archaeological Museum, Kabul 41

Sun and Moon Gods. Wall Painting from Niche K of the Buddhist Monastery of Fondukistān. Probably
Seventh Century. Archaeological Museum, Kabul (copy by J. Carl) 125

Wooden Votive Tablets from Dāndān Öilüq (Khotan). Probably Seventh Century. British Museum,
London:
— The "Silk Princess," detail. Sanctuary D X. (7½×4⅝″) 56
— The "Iranian Bodhisattva." Sanctuary D VII. (13×8¼″) 57
— Scene from a Khotanese Religious Legend. Sanctuary D VII. (13⅛×7″) 59

Buddhist God of the Tantric Type with Symbols of the Sun and Moon. Wall Painting from Balawaste.
Seventh-Eighth Centuries. (Height c. 12″) Bal. 0200, Collection of the National Museum, New Delhi 60

Buddha beneath a Canopy. Wall Painting from Qočo. Seventh-Eighth Centuries. (Height c. 8″) I B 8731,
Indische Kunstabteilung, Staatliche Museen, Berlin 97

EIGHTH CENTURY

Divinities of the Tuṣita Heaven. Wall Painting from the Cave of the Apsaras, Qumtura. Eighth Century.
(Height 18⅛″) I B 9021, Indische Kunstabteilung, Staatliche Museen, Berlin 89

Details of Wall Paintings from Shrine XII, Bäzäklik. Eighth Century. Bez. XII, A-B, Collection of the
National Museum, New Delhi:
— Kneeling Buddha. (Average width 21½″) 98
— Musicians and Mourners. (Width c. 19½″) 100

Musicians. Wall Painting from Bäzäklik. Eighth Century. Private Collection, Tokyo 103

Figures mourning for the Death of the Buddha. Wall Painting from Shrine IX, Bäzäklik. Eighth
Century. (Width c. 23½″) 5 Bez. XI, A-C, Collection of the National Museum, New Delhi . . . 110

Lady and her Maid beneath a Tree. Scroll Painting from Astāna (Turfān). Eighth Century. (58¾×22½″)
Hakone Museum (Japan) 118

Detached Leaf of a Manichaean Manuscript, painted on both sides, detail. Painting on Paper from Qočo.
Eighth-Ninth Centuries. (Width 2″) I B 4979, Indische Kunstabteilung, Staatliche Museen, Berlin 3

Buddha (Amitābha?) with Halo and Nimbus, worshipped by Three Deities and a Monk. Wall Painting,
probably from the Temples of the Sängim Gorge, near Turfān. Eighth-Ninth Centuries. (Width
18½″) I B 6871, Indische Kunstabteilung, Staatliche Museen, Berlin 34

Worshipping Bodhisattva. Wall Painting from Qumtura. Eighth-Ninth Centuries. (Height 23⅞″)
I B 8377, Indische Kunstabteilung, Staatliche Museen, Berlin 91

Offering Scene: Deva in Adoration. Wall Painting from Shrine I, Bäzäklik. Eighth-Ninth Centuries.
(Average width 17¾″) 3 Bez. I, M-N, Collection of the National Museum, New Delhi 99

Uighur Prince. Wall Painting from Temple 19, Bäzäklik. Eighth-Ninth Centuries. (Width 8⅜″) I B 8381,
Indische Kunstabteilung, Staatliche Museen, Berlin 106

Demon. Fragment of an Uighur Scroll. Indian Ink on Paper. From Area X, Qočo. Eighth-Ninth
Centuries. (Height 6½″) I B 4951, Indische Kunstabteilung, Staatliche Museen, Berlin . . . 108

Monks or Disciples. Wall Painting from Ming-oï XIII, near Šorčuq. Eighth-Ninth Centuries (?). (Width
27½″) 18. Mi. XIII 10, Collection of the National Museum, New Delhi 92

Female Donors. Wall Painting from Cave VII, Šörčuq. Eighth-Ninth Centuries (?). (Height 8¾″)
 I B 9127c, Indische Kunstabteilung, Staatliche Museen, Berlin 93

NINTH CENTURY

The Future Buddha renouncing the World. Wall Painting from Qočo. Ninth Century. (Height 10¾″)
 I B 4426, Indische Kunstabteilung, Staatliche Museen, Berlin 26

Uighur Princess. Wall Painting from Bäzäklik. Ninth Century. (Height 21¼″) I B 6876b, Indische
 Kunstabteilung, Staatliche Museen, Berlin 107

The Thousand-Armed Bodhisattva Avalokiteśvara. Painting on Paper from Tun-huang. Ninth Century.
 (15×12¼″) Musée Guimet, Paris 120

The Bodhisattva Kṣitigarbha with the Judges of the Lower World (below) and the Paradise of a Supreme
 Buddha (above). Scroll Painting on Hemp from Tun-huang. Mid-Ninth Century. (50×26¾″) Musée
 Guimet, Paris . 117

Dhṛtarāṣtra, Ruler and Guardian of the East. Painting on Silk from Tun-huang. Probably Ninth
 Century. (Width 11¾″) Musée Guimet, Paris 116

Uighur Prince. Detail of a Banner found at Qočo. Ninth Century (?). (Width c. 14″) I B 7323, Indische
 Kunstabteilung, Staatliche Museen, Berlin 105

Wall Paintings from the Nestorian Temple at the Eastern Gate, Qočo. Late Ninth Century. Indische
 Kunstabteilung, Staatliche Museen, Berlin:
— Palm Sunday (?). (23½×25″) I B 6911 112
— Worshipper. (17⅛×8¼″) I B 6912 113

Bodhisattva. Silk Embroidery on a Cotton Fabric from Qočo. Ninth-Tenth Centuries. (Height 15″)
 I B 4796, Indische Kunstabteilung, Staatliche Museen, Berlin 50

Demon with a Lamp. Wall Painting from Temple 9, Bäzäklik. Ninth-Tenth Centuries. (c. 25×10″)
 I B 6875, Indische Kunstabteilung, Staatliche Museen, Berlin 102

Dragon leaping out of the Water. Wall Painting from Temple 19, Bäzäklik. Ninth-Tenth Centuries.
 (Height 25⅛″) I B 8383, Indische Kunstabteilung, Staatliche Museen, Berlin 109

TENTH CENTURY

Bodhisattva with an Elaborate Crown. Painting on Silk from Area K of the Ruins of Qočo. Tenth
 Century. (Width 10″) I B 6166, Indische Kunstabteilung, Staatliche Museen, Berlin 33

PUBLISHED AUGUST 1978

PRINTED BY

IMPRIMERIES RÉUNIES SA

LAUSANNE

PHOTOGRAPHS BY

Maurice Babey, Basel (pages 3, 18, 22, 23, 24, 25, 26, 30, 33, 34, 37, 38, 39, 41, 49, 50, 52, 54, 55, 60, 62, 68, 70, 72, 73, 74, 75, 76, 77, 79, 80, 81, 84, 85, 88, 89, 91, 92, 93, 97, 98, 99, 100, 102, 105, 106, 107, 108, 109, 110, 112, 113), L. R. Adrion, Paris (pages 116, 117, 120), Henry B. Beville, Washington (pages 82, 86, 87, 103, 118), Scala, Florence (pages 64, 65), Zoltan Wegner, London (pages 56, 57, 59). Other photographs obligingly lent by Mr Richard Ettinghausen (pages 44, 45, 46).

PRINTED IN SWITZERLAND